The Yoga of Draw

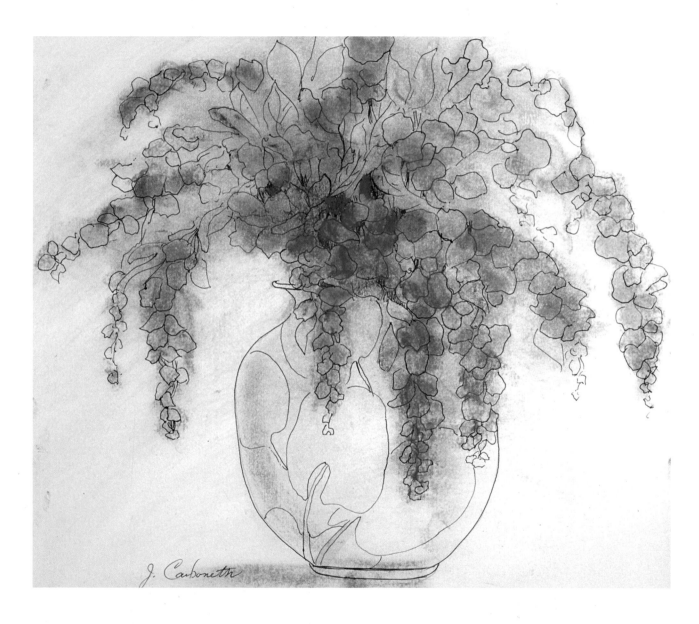

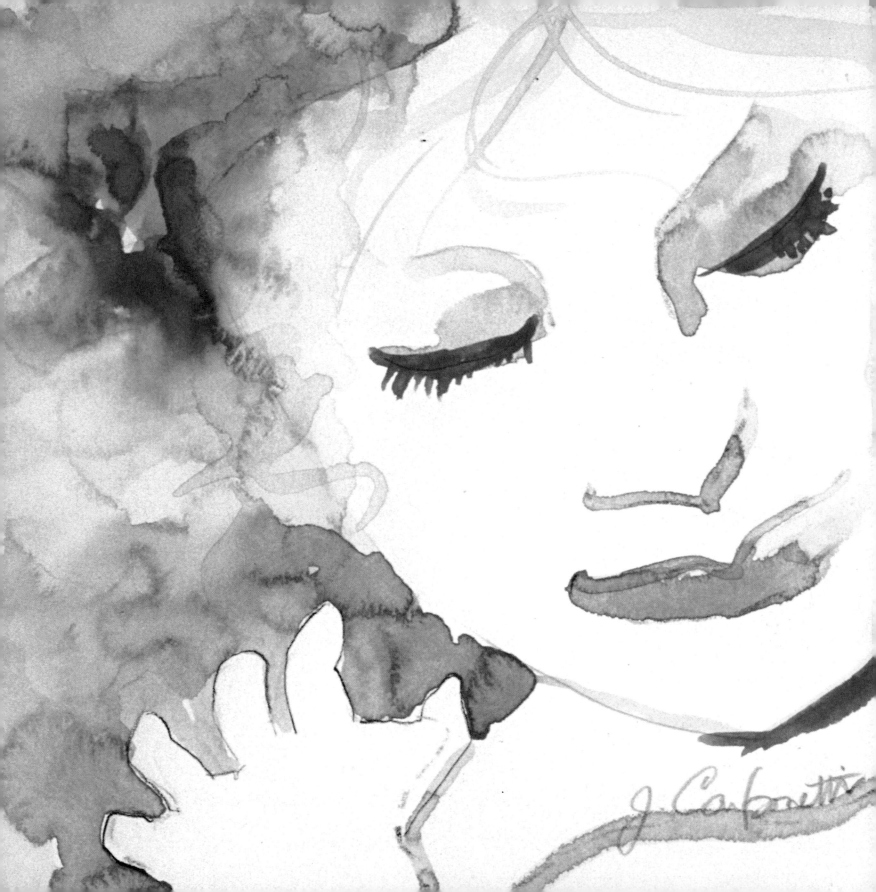

The Yoga of Drawing

Uniting Body, Mind, and Spirit in the Art of Drawing

Jeanne Carbonetti

WATSON-GUPTILL PUBLICATIONS/NEW YORK

To my nieces Megan, Kimberly, Samantha.
May you see yourselves through my eyes
and know how beautiful you are.

Front cover
Jeanne Carbonetti
WISTERIA
Pastel on toned paper, 15 × 15" (38 × 38 cm), 1998. Collection of the artist.

Frontispiece
Jeanne Carbonetti
JAPANESE VASE WITH WISTERIA
Pastel with pen and ink on paper, 14 × 16" (36 × 41 cm), 1998.
Collection of the artist.

Title page
Jeanne Carbonetti
MOTHER AND BABY
Watercolor on paper, 5 × 13" (13 × 33 cm), 1998. Collection of the artist.

Contents page
Jeanne Carbonetti
THE EROS WOMAN
Watercolor on paper, 19 × 14" (48 × 36 cm), 1991. Collection of the artist.

Senior Acquisitions Editor, Candace Raney
Edited by Robbie Capp
Designed by Areta Buk
Graphic production by Hector Campbell
Text set in 11.5 Adobe Caslon

ALSO BY JEANNE CARBONETTI

The Tao of Watercolor:
A Revolutionary Approach to the Practice of Painting

The Zen of Creative Painting:
An Elegant Design for Revealing Your Muse

ABOUT THE AUTHOR

Painter **Jeanne Carbonetti** instructs creative workshops and art classes in her hometown, Chester, Vermont, where she is owner and director of the Crow Hill Gallery and Art Center.

Library of Congress Cataloging-in-Publication Data
Carbonetti, Jeanne.
 The yoga of drawing : uniting body, mind, and spirit in the art of
drawing / Jeanne Carbonetti.
 p. cm.
 Includes bibliographical references and index.
 ISBN 0-8230-5972-3
 1. Drawing—Psychology. 2. Form perception. 3. Self-perception.
4. Yoga. I. Title.
NC715.C27 1999
741'.01'9—dc21 99-18113
 CIP

Printed in China

First printing, 1999

1 2 3 4 5 6 7 8 9 / 07 06 05 04 03 02 01 00 99

Acknowledgments

I wish to thank all those who contributed to the birthing of this book. My gratitude goes to Claire Gerus, my agent; to photographer George Leisey and slide specialists Tim Sturgeon, Tom Longfellow, and John Preston; to artists Marilyn Clough, Carmen Fletcher, Elizabeth Gardiner, Michelle Holt, Alexis Kyriak, Nancy MacKenzie, Shirley Mission, Jane Philpin, Heidi Richter, Zena Robinson, and Mark Seidensticker; and to Hank Hammond, computer wizard and general magician.

As *The Path of Painting* Series draws to a close, I express appreciation to my friends at Watson-Guptill Publications: to Candace Raney, who took it as a sign when my first manuscript crossed her desk twice in one day; to editor Robbie Capp, whose diamond clarity of thought is polished by a willingness to listen; and to Areta Buk, whose intuitive sense of design gave form to the spirit of these books.

Finally, I offer my sincere gratitude to the teachers who directed my own path, which led to this series: to Ruth Wilson, my first watercolor teacher, who opened a new world to me; to Kathy Daigle, yoga teacher and talented bodyworker, whose perceptive ability to read the energy of my body has taught me to trust its wisdom; to Glenn Gurman, teacher and founder of the White Star School of Kung Fu in Norwich, Vermont, whose courses in Tai Chi, Pakua, and Meditation have taught me to find the one behind the many; to Larry Carbonetti, my husband, whose noble passion for truth and honor teaches me daily to be fearless in my beliefs; and to the One behind the many, which is the true voice within these books, thank you.

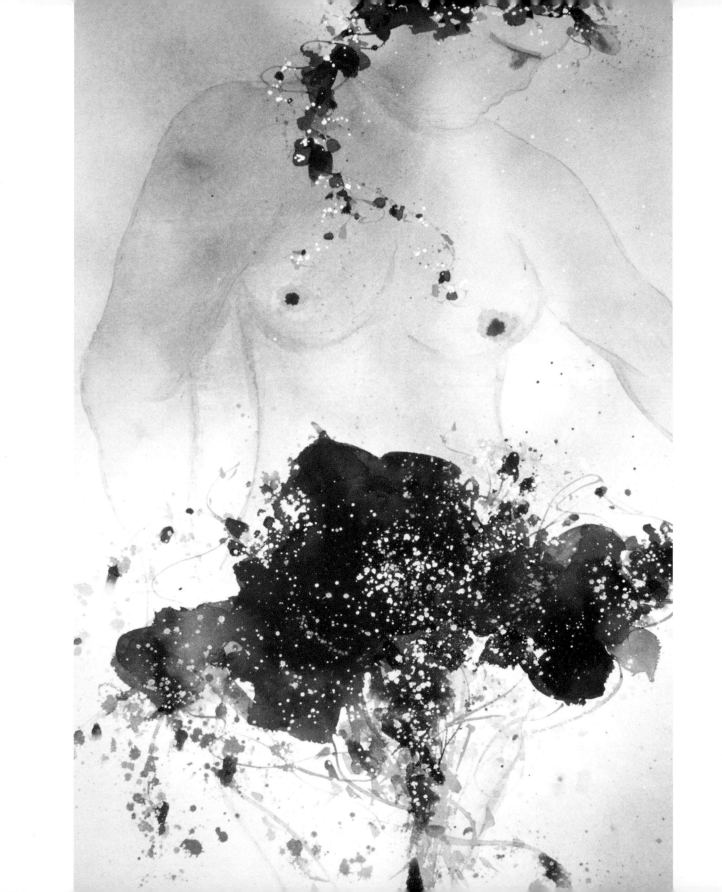

Table of Contents

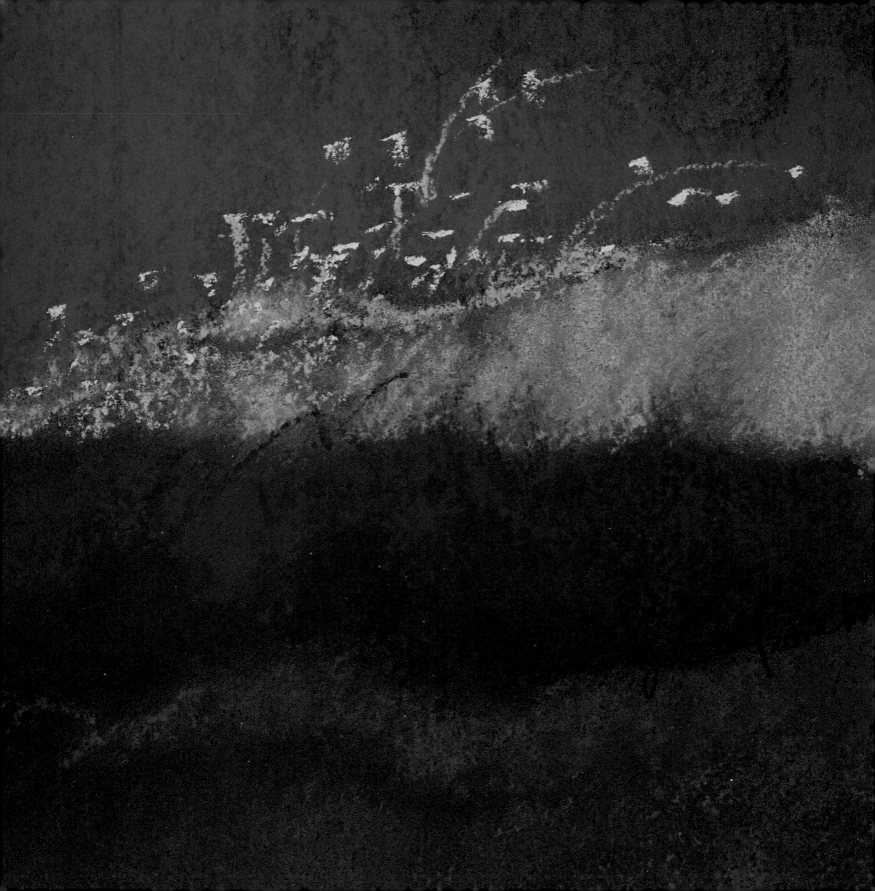

Being; the Meaning of Yoga

Taken from the Sanskrit, the word *yoga* means union, and every form of yoga has as its fundamental intention to bring together body, mind, and spirit as one unit in the present moment. As in all Eastern inner arts, the supreme goal of this endeavor is the bliss of *being,* as opposed to the toil of *doing.* It is the experience of the eternal, of the timeless, of the unity underlying all things, and it is believed to be achieved whenever body, mind, and spirit are one.

Yoga quite literally means "yoking the mind," historically represented by a graphic image of oxen with their yokes, ready to work under guidance of their master. It is an image that captures the essence of the task at hand in drawing, which is to bring the powerful potential of thinking mind's awareness into a supporting role for the body. In yoga, balance is essential, and the performance of the body in movement or posture cannot be accomplished without the mind's full presence. In yoga, the body is master, and mind, the valuable servant.

My own metaphor is that of a powerful stallion running wild. That is our Logical Mind, the yang, or assertive, thinking part of us. A wonderful animal, but running wild it does us little good and likewise scatters its own energy. In yoga, we use our Body Mind, the yin, or receptive part of us, to corral the fiery stallion of Logical Mind, to bring it into an awareness of how the body feels. Body and mind come together, and relationship can begin, fostering the union that releases spirit into the bliss of being.

This is precisely what drawing does. It brings the power of the mind and its ability to focus into a coordinated effort with the body's impulse to move and make a mark—in effect, to create. Mind sees, body feels and responds, and the two become one in the birth of true sight. That union of body and mind in drawing, as in yoga, creates the opening by which love enters, for Heart Mind, owner of our spirit, never forces its way, but waits until it is allowed. In that moment, the stallion has its perfect rider, and Spirit, Mind, and Body are one seamless unit of power, attention, and love. The division melts away as my hand becomes the hand that I draw—that finger, that curve is mine. It is a remarkable thing, experienced by many, that anything we bother to draw becomes overwhelmingly beautiful to us.

Drawing, then, like yoga, not only honors the unity of parts of ourselves, but also a union with our subject, so while the art of drawing begins in the eye, it always ends in the heart.

Jeanne Carbonetti
TUSCAN AUTUMN
Pastel on paper, 8 × 8"
(20 × 20 cm), 1998.
Collection of the artist.

The Italian landscape has a richness that matches the Italian spirit, an intensity that I chose to make the real subject of this piece, rather than an analytic lay of the land. Perceiving is recognizing the inner intent of a subject, not just seeing what is on its surface.

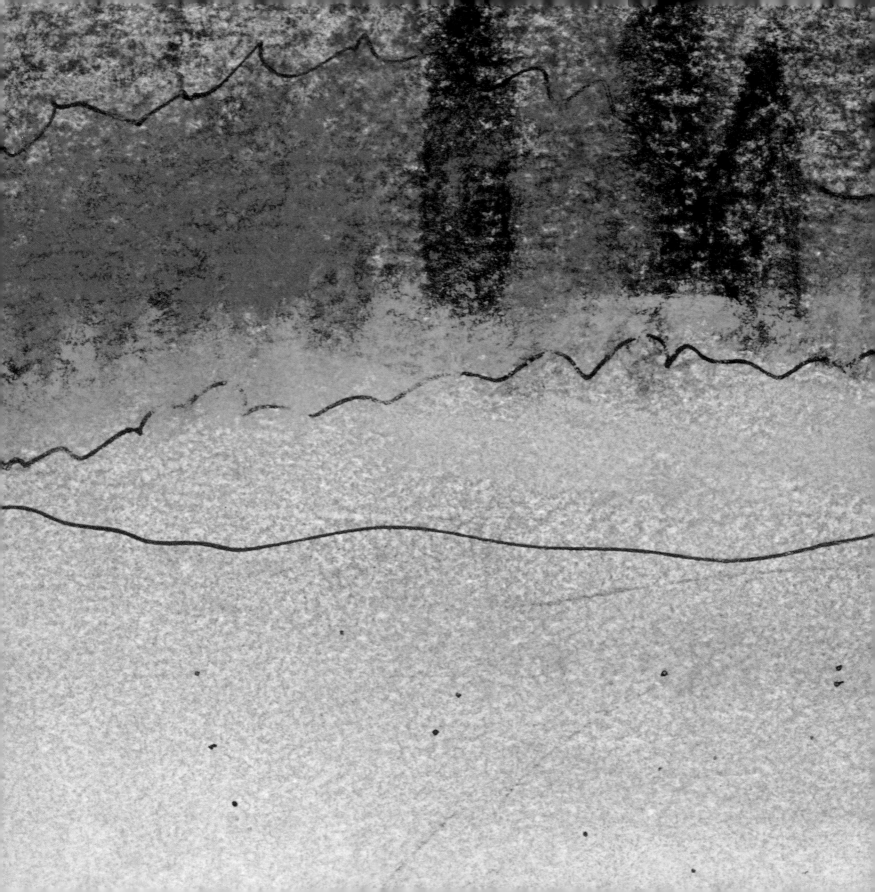

Introduction: Perceiving

Now and then

the lightning strikes for them. . . .

And from a thousand roses,

they deduce the rose.

Robert Beverly Hale

Jeanne Carbonetti
TUSCANY PINES (DETAIL)
Pastel with ink on paper, 3 × 7"
(11 × 18 cm), 1998.
Collection of the artist.

Luscious spring mustard fields against
rich pines made me want to emphasize
its diffused quality. This, in turn, led me
to choose a distance and size that would
allow soft focus to be the real subject.

11

The Practice of *Opening*

Meditation

To bring all your awareness to this one moment, take a deep breath and as you exhale, imagine all bodily tension draining through your feet. Take a second deep breath as you imagine all your thoughts floating out the top of your head. With a third deep breath, let your body sink into relaxation.

Focusing on your legs, imagine that all your energy circuits are being pulled back into your feet. Your body is now fully present. Next, bring your awareness to your third eye (between your brows) as you picture all your circuits of thought energy being pulled back in. Now focus awareness on your heart. Imagine all the cords of energy you have extended outward being pulled back in at your request. State your intention aloud: "I am now fully present, Body, Mind, and Spirit. I am one."

The quote on the preceding page is from master teacher Robert Beverly Hale, who wrote both for and about his drawing students. But he could have been describing students of meditation as well. In a broad sense, drawing *is* a meditation, for it seeks to still the thinking mind and bring it into union with other parts of the self, so essential to being fully in tune with the subjects we draw, for it is not only Logical Mind that perceives, but Body Mind and Heart Mind as well.

But first the mind must be quieted into the task of seeing, and two forms of meditation serve as examples of how this can be achieved. In insight meditation, thinking mind notices bodily sensations, emotions, and thoughts, but its directive is simply to recognize them and let them pass. In this way, thinking mind has enough to do to keep it occupied, but not enough to cause trouble. In transcendental meditation, Logical Mind has a similar job. It repeats a mantra—a phrase or syllable, such as *om*—giving the mind a chance to slow down gently, like a child being read a bedtime story. Likewise in drawing, success lies in giving the mind enough to do that it stays busy, but is not given the authority to judge. Since Logical Mind loves to reach conclusions, if there's nothing to judge but simply to witness, it gets drowsy and quiet rather quickly. It is this critical step in the process of drawing that Betty Edwards made famous in her wonderful book, *Drawing on the Right Side of the Brain*. Logical Mind (left brain) must step aside and allow right brain—what I call Body Mind, our unconscious, instinctive side—to take over for the act of true seeing. In my further interpretation, Heart Mind, the synthesis of the two other ways of perceiving, soon begins to satisfy both.

So then, drawing is first about taking something in with all the senses, letting what is, simply be as it is, without judging it. When this is accomplished, drawing, like meditation, becomes an unfolding of deeper and deeper layers of structure until the essence of a thing is revealed. This awareness is a second, quite profound parallel to meditation—a penetration to a deeper level of knowing until in drawing this rose, I may suddenly understand the very essence of "roseness," and feel at one with it. This kind of seeing takes time and practice and even then, it comes by what seems an act of grace. But one thing is certain: When it comes, and the lightning of perception opens, it is always a beautiful experience.

Jeanne Carbonetti
VASE OF FLOWERS
Watercolor on paper, 6 × 5"
(16 × 13 cm), 1998. Collection of the artist.

Executed like a sumi-e ink drawing, every stroke in this watercolor was a deliberate shape created in response to the one before.

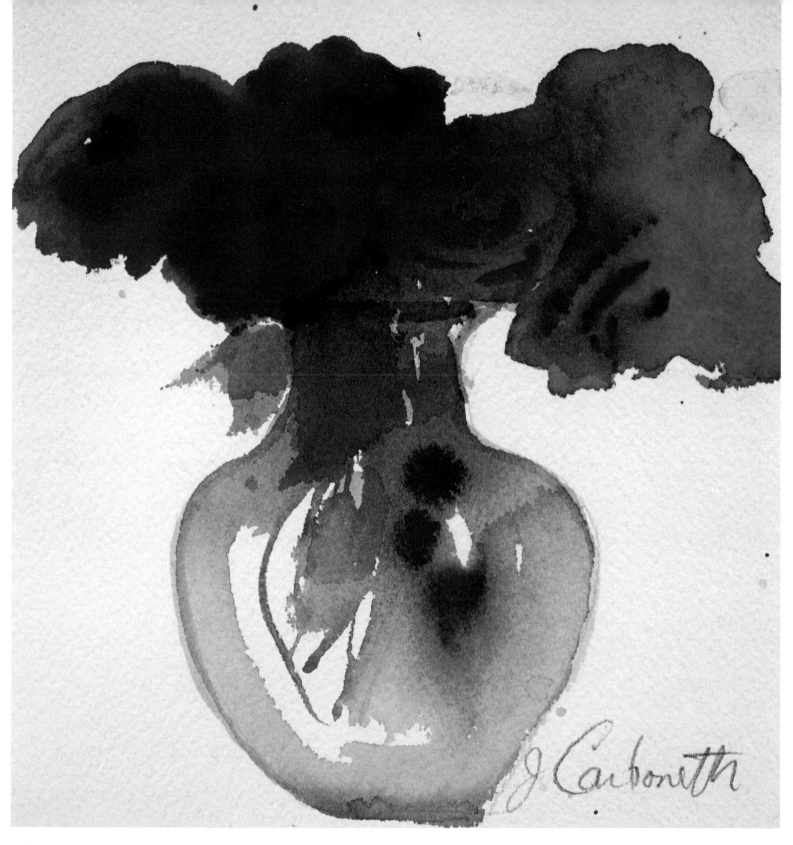

The Art of *Contemplation*

So how does one approach this meditation of drawing, confident of success? I believe it is by allowing the natural unfolding of body, mind, and spirit to carry you, like an ocean wave, to your own creative crest. What is natural and unique to you is perfect for you; you need only to see and trust it as you follow some basic techniques related to gesture, mass, contour, and the more elusive, deeper structures that take a form and its essence to the final details of a drawing. Moving in this way allows you to work from your natural strengths and even biorhythms to overcome tedium and fear of failure.

For all of us who have physical sight and can hold a pencil, the potential for beautiful drawing is present. But too often in my experience as a teacher, I have found students wanting to rush ahead in a manner that is antithetical to good drawing. The exercises presented throughout this book will encourage you to work from broad, general principles, but slowly, with lots of room for play and movement, down to the more precise, specific, and careful concentrations of realism and drawing. The time it takes to let the spirit be revealed begins to turn us inward to introspection, and this, in turn, opens the doors of perception wider. Then it is an easier step to the full attention that is required for the art of wonderful drawing.

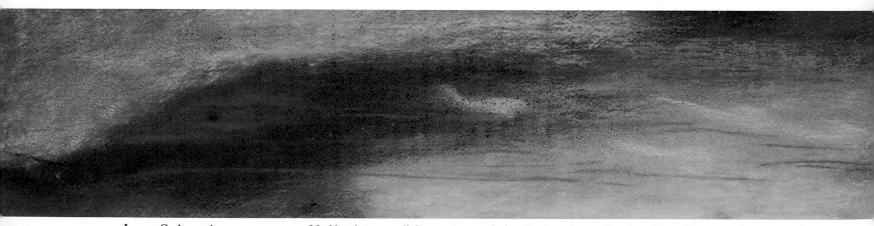

Jeanne Carbonetti
GOLDFISH
Pastel on toned watercolor paper, 4 × 26"
(11 × 66 cm), 1998. Collection of the artist.

Nothing is too small for our contemplation. In fact, the smaller the subject, the greater the opportunity for looking beyond the ordinary. Here, little golden dashes of fish give focus to the fluctuating values of the water around them.

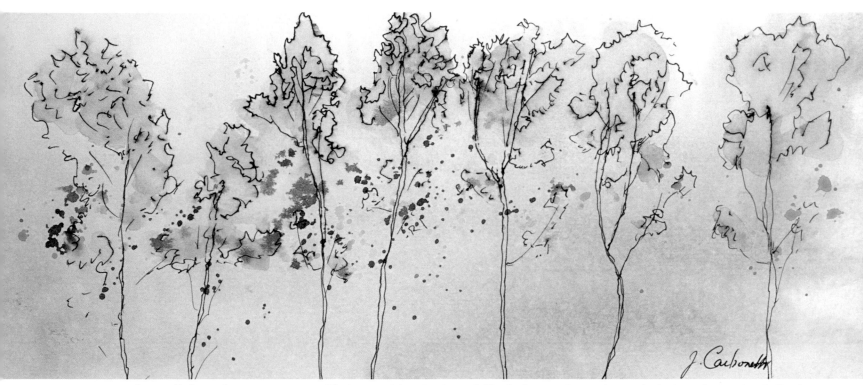

Jeanne Carbonetti
POPLARS IN A ROW
Pen and ink with wash on toned paper, 3 × 10"
(5 × 25 cm), 1998. Collection of the artist.

The beauty of drawing is much like the beauty of yoga: they are both about the practice of allowing body, mind, and spirit to come together in their own special rhythm. The end of both is to allow all things to be just as they are, to celebrate the one life force as it manifests into its many and varied forms.

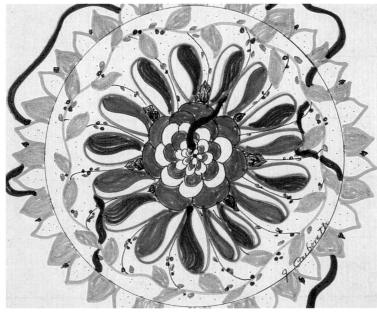

Jeanne Carbonetti
CHRISTMAS MANDALA
Markers on paper,
8½ × 11"
(22 × 28 cm), 1993.
Collection of the artist.

A mandala ("magic circle" in Sanskrit) is fascinating to produce and to read, somewhat like interpreting a dream. While this form of drawing comes from the imagination, using mainly abstract shapes and forms, it often reveals important aspects of our true psyche.

15

How to Use This Book

As with my two earlier books in this series, this instructional should be read through once before you begin the hands-on exercises it contains. Then as you begin to work on particular projects, your familiarity with my method and its underlying principles will guide you through the book—and on to all future drawing sessions.

The book is divided into three parts, Body, Mind, and Spirit, each unfolding into the next. "Body" encompasses the chapters "Receiving," "Feeling," "Seeing," and "Touching," in which your natural sense of movement takes you through gesture and contour drawing from the world of Logical Mind (left brain) to the world of Body Mind (right brain), where seeing relationship opens the path to drawing. Then you are ready to flow outward to the "Mind" chapters, "Simplifying" and "Choosing," where Logical Mind offers you its talent for clarity, aiding your ability to see underlying patterns in forms. Finally, "Spirit" chapters "Expressing," "Exploring," and "Loving" reveal what Heart Mind contributes—the rewards of learning to see with fresh eyes, of practicing the act of honoring, rather than judging.

Yoga principles drive this approach. Applied to drawing, patience and understanding guide your work instead of judgment and hasty conclusion. In fact, drawing conclusions has little to do with drawing at all. For me, above all, drawing out the mystery is what drawing is about. It is what turns the skill of rendering into the heart and art of revealing. Each time we draw, we ask a new lover to dance for the very first time. And who would say no to such a pleasure?

Jane Philpin
UMBRELLA
Pen and ink with wash,
8 × 12" (20 × 31 cm), 1998.
Collection of the artist.

Sometimes the simplest subjects can speak profoundly. I can't help but think of this simple object as a Zen umbrella, a lovely metaphor of emptiness that is full. The use of the primary colors red and blue seem to accentuate the fundamental truth of its presence, its perfect right to simply be.

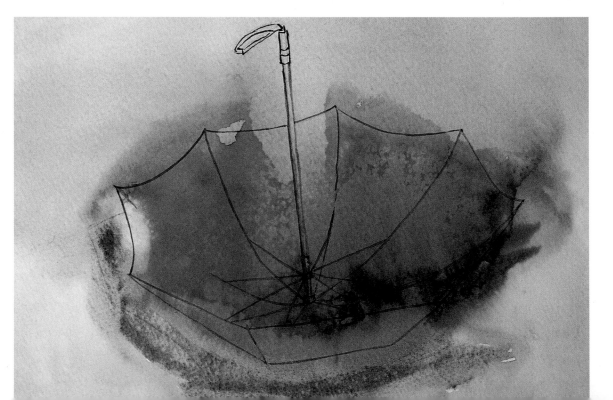

Jeanne Carbonetti
ENGLISH POPPIES IN GLASS BOTTLES
Pen and ink with wash on paper, 10 × 9" (25 × 23 cm), 1998.
Collection of the artist.

As reference for larger drawings or paintings, I find that quick studies in pen and ink with wash work better for me than photographs to establish my connection to a subject. What attracted me to this grouping was the whimsical lineup of delicate green bottles, and the rhythm of limpid flowers —like laughing maidens in a row.

Jeanne Carbonetti
THE YELLOW ROSE
Pen and ink with wash on paper, 8 × 6" (20 × 16 cm), 1998.
Collection of the artist.

The strength of this rose's delicate color seemed a beautiful paradox and a message for me as an artist: I must never forget the power of beauty to heal.

17

Receiving

We have faced each other for eons.

How is it possible we have never

seen each other?

Frederick Franke

Carmen Fletcher
FACE OF A FRIEND
Watercolor on paper,
22 × 15" (56 × 38 cm), 1997.
Collection of the artist.

Receiving requires a willingness to be
with your subject until it reveals its essence
to you. Using just such patience and only
a few brushstrokes, Carmen captures a
penetrating and wistful personality in
this drawing.

The Practice of Sensing

Meditation

To approach your drawing nonjudgmentally, take three big breaths and let go of all tensions in your body, mind, and spirit.

Now, pretend you've just arrived here from another planet. Everything before you is new and wonderful and strange, including that last drawing you've just completed. You're not invested in how anything around you operates. You're not focused on whether your drawing should look a certain way. Instead, you allow yourself the freedom to simply watch, simply receive.

Receiving is the art of taking something into your awareness with all the power of your senses. It's the art of allowing, rather than reacting; being receptive, rather than active, very akin to the way animals react to each other. I am often fascinated by that stillness that occurs when two dogs meet. They stop and stare at each other for several long moments as they sniff the air with concentrated alertness. They become an island of silence as they proceed ever so slowly to come closer, to go around, to see, hear, feel all the parts of this "other" in an encounter that slows time.

Children have the same instinct, that frozen pause as they behold you. I still remember an episode on a crowded street years ago, when I spotted a little girl, about three years old, through the window of a parked car. She fixed her eyes on me straight on, her demeanor unflinching in its openness, neither happy nor sad nor searching, but simply open. Time stopped. The world went into soft focus and silence as our eyes locked. It was simply this little girl and me. We shared a look—no, a looking—for several moments. Then just as suddenly, as if all her receptors had told her, "This is good," she broke into an enormous smile that was truly meant for me. It was a great gift that remains one of the special moments of my life.

There is profound intimacy and empathy in such an encounter. *Empathy*—being with—is what receiving is all about, and it's the first step in drawing anything. I wish to emphasize *anything,* for the principles of drawing remain the same, no matter what the subject may be. My method is not to teach how to draw a barn or a rose or a face, because each will always be different from all others. While the deep structures of barns, roses, and faces can be revealed over time, I don't think it's wise to start there, because such learning keeps you in an active mind, focused on tedious and exacting formulas, instead of allowing your senses and spirit to guide you.

So how do you receive that barn, rose, or face? It comes down to two simple secrets to drawing: *See the shape and feel the feeling.* If you remember and embrace that phrase, you'll be able to draw anything your heart desires. Applied to technique, "see the shape," refers to contour drawing; "feel the feeling" refers to gesture drawing. Both methods are taught classically in art schools, but my particular approach stresses a specific order and application of these two methods, on which this entire book is based.

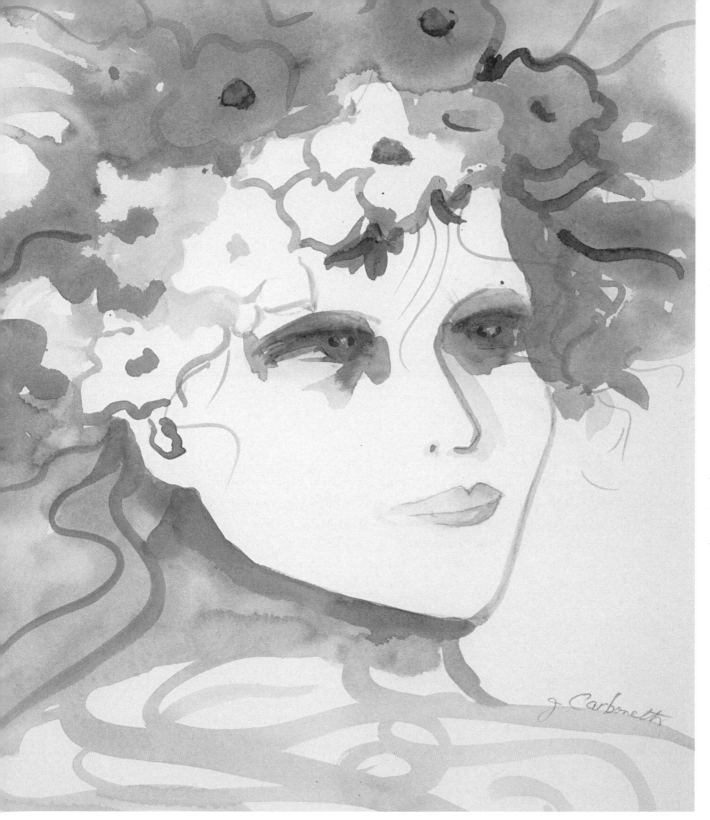

Jeanne Carbonetti
Aphrodite 1998
Watercolor on paper,
10 × 9" (25 × 23 cm),
1998. Collection of
the artist.

In my mind's eye, I received a goddesslike face with a garland of flowers, and worked outward from there. What soon surprised me was the power of those eyes and the energy of that hair. It was then that I knew I had Aphrodite, the great mother of Eros and protector of sensual feeling. How appropriate that she found her home in a book that seeks to amplify our sensual sensitivity. Working from imagination can be powerful both technically and thematically.

Understanding Gesture and Contour

Drawing is often approached from the outside in—making an outline of an object, then filling in interior details—in effect, putting both gesture and contour together in one unit, as a sketch to be judged and corrected along the way. The sketch is primarily a function of left brain's assertive, thinking side.

My approach is exactly the opposite. I believe that gesture and contour are two separate steps in drawing. Gesture drawing—which starts from the inside and works out—must come first. Contour, an outline of the form, comes second. Both are studies, moving from quick lines to slow lines, but in neither case does this method seek to judge correctness. It only discerns the next response. The *study* is a function of the right brain's receptive, feeling side.

Here are the essential differences between gesture and contour drawing.

Think of gesture as a scribble picture. Gesture helps you to mass in a form on your paper so that it fits, enabling you to establish proportions; for example, if it's a figure drawing, how big the head needs to be in relation to the torso, how far over the arm protrudes, and so on. By beginning with gesture, you can scribble to your heart's content, going over and over the form. Gesture is exploration, nothing else. There are no mistakes to make, only more knowledge to discover.

After establishing the size of your form, the second gift gesture reveals is the movement of the form, the life force behind it. Now you begin in a very large, expressive way, to build your object from the inside out. This aspect of gesture drawing enables you to warm up and eliminate a lot of nervous energy in the expressive act of scribbling. Since you move around vigorously without worrying about lines, you naturally begin crossing a threshold into your more receptive side, the one that always sees the big picture, how the pieces fit together.

Contour drawing is concerned with edges: broadly speaking, an outline of the form, including any denotations of important shapes within the form. In a traditional sense, a contour drawing is executed in one continuous line. Think of the classic contour exercise of drawing an outline of your hand while not looking at the paper at all, a wonderful illustration of how well coordinated hand and eye can be when we let them really work together. The purpose of a contour study is to hone such hand-eye coordination. It's accomplished by going very slowly through the process of seeing and drawing, until the hand moves with the eye. Together and in this order, gesture drawing helps you see the whole form, which eases you into the deeper concentration of contour drawing.

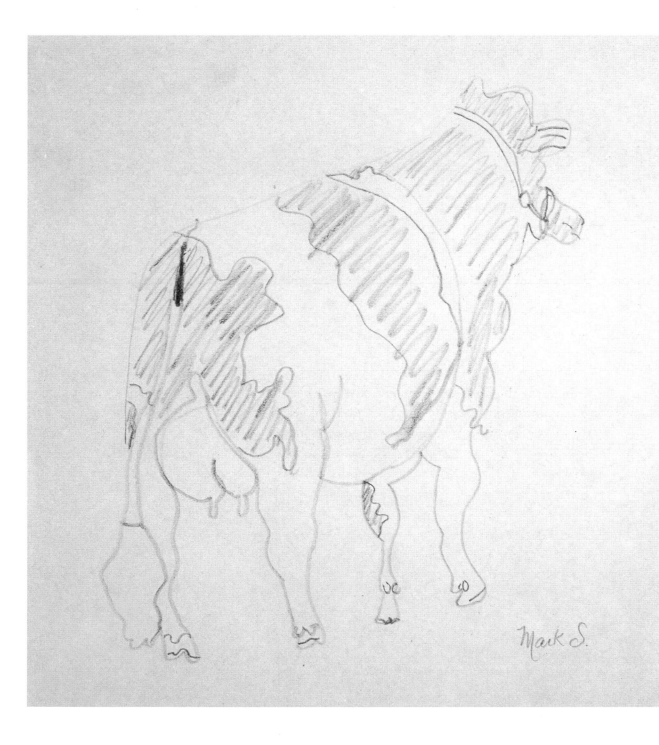

Mark Seidensticker
Quick Contour
of Celsius
Pencil on paper,
17 × 15" (43 × 38 cm),
1998. Collection of
the artist.

*Mark seems to like
quick contours as much
as I do. After gesture
drawing with lots of
scribbles on another
study sheet, Mark did
a quick contour as a
transition into the
slower, full contour.
His special calligraphy
for shading and
detailing the hooves
not only captured
Celsius's contour, but
her personality as well.*

Exercise: The Art of the Study

Materials

- photo of a figure
- board to hold paper
- 2 sheets of 16 × 20" tracing paper
- 1 sheet of 16 × 20" drawing paper
- #6B pencil
- marker pens
- sumi-e ink (or black watercolor)
- watercolors and brush

This exercise is the prototype for studies in subsequent chapters, for they are all based on my stepped approach to drawing, detailed below. To summarize the steps briefly here: Begin with a gesture pencil drawing on one sheet of tracing paper (which is then discarded); next, do a contour pencil drawing on a separate sheet of tracing paper, refine it, then go over your lines with a marker to make them clear and bold; then transfer your drawing to good paper (via pencil carbon rubbed on the back of the contour tracing sheet); finish your transferred drawing on good paper in a medium of your choice. In effect, the contour drawing is a pattern (much like a sewing pattern) for further, ongoing renditions of the subject in varied mediums. In my two examples shown (pages 26, 27), I used sumi-e ink in one version, watercolor and ink in the other.

Step 1: *Mount Papers.* Attach a sheet of drawing paper to your board, then mount both sheets of tracing paper over it. Using tracing paper will help you remember that your first steps are not final art, so you can relax.

Step 2: *Draw a Box.* With a marker, draw a frame to contain the gesture drawing to be made (see example on facing page in red marker). Be careful to just touch all the edges, so that your box guides the visual space that your figure fills. Mark halfway points on each side. This important step helps with proportions in relating one part of a drawing to other parts of it.

Step 3: *Gesture Drawing.* Now, copying from your reference photo of a figure, begin your gesture drawing within that box. Gesture scribbling gives you a kinesthetic connection to your subject as you seek to understand the movement and sweep of it, how it stands or sits or leans in space.

Steps 4 and 5: *Contour Drawing.* First, remove the gesture drawing from your board and work on the fresh sheet of tracing paper beneath. Then with pencil, make a box again as before, marking halfway points on it, and begin your contour drawing anywhere you like, moving slowly, pausing at juncture points to check proportions. Keep your pencil on your paper and your eyes more on your photo than on your drawing. If you need to adjust a line, do so without erasing. Even if your shapes are a bit off right now, overall proportions will be correct. Then go over your pencil line with a bold marker (as in my example on facing page; visible pencil scribbles there are explained in Step 6).

Jeanne Carbonetti
GESTURE STUDY OF ANNIBALE CARRACCI'S STANDING FIGURE
Red marker on tracing paper, 9 × 6" (23 × 16 cm), 1994.
Collection of the artist.

Here you see the box that gave me a frame of reference, marked at the halfway point along each side to guide proportions. Using a figure found in an old master's work, my gesture drawing within the box helps me to know my subject. I often talk to myself as I scribble my gesture ("Ah, the neck is turned forward here!"), which allows my mind to stay occupied in a harmless way until it finally gets bored and takes a nap.

Jeanne Carbonetti
CONTOUR STUDY OF CARRACCI'S STANDING FIGURE
Pencil with red marker on tracing paper, 9 × 6" (23 × 16 cm), 1994.
Collection of the artist.

After I've loosened up and become acquainted with my subject, I'm ready for the contour drawing. I work very slowly, looking much more at my subject than at my paper, which almost guarantees that my proportions will be generally accurate.

Step 6: *Refining.* Looking at your drawing, you'll see that although you've done no real fixing prior to this, the general shape and movement of your form is correct. Even if the head needs to be a bit larger, or a leg more shapely, by working carefully from gesture to contour, you've ensured that only minor refinements will be needed. Once you're satisfied, go over your lines with a marker to make them clear and bold. Then, on the reverse side of your contour tracing paper, pencil scribble markings along your refined contour outline (as shown in the figure on the previous page). As you do so, the carbon from your pencil will be useful in your next step, when you transfer your contour to good drawing paper. Turn the sheet face up again in preparation for that transfer, as described in the next step.

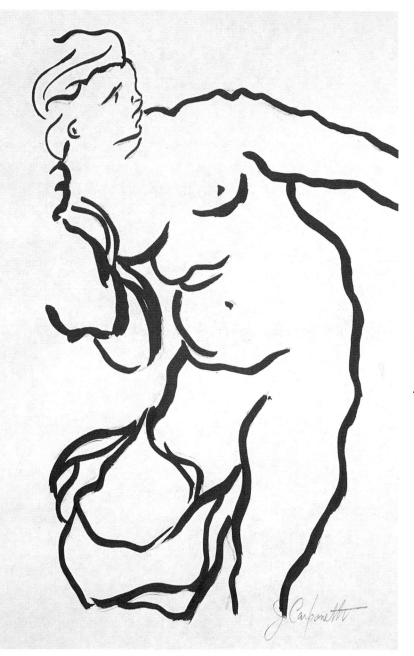

Step 7: *Transferring.* With your contour drawing face up, now trace over your marker contour with a pencil. As you do so, the carbon markings that you made on the reverse side will transfer to your clean sheet of drawing paper beneath. The carbon will be pale, so you'll be able to work over it to finish your drawing in the medium of your choice.

Step 8: *Finishing.* Once your contour drawing is transferred to good paper, the possibilities for finishing it are limitless. Your contour pattern can be used over and over again, serving you for multiple impressions, each one finished in a different way. Just two of the many possibilities are shown in examples here and on the opposite page.

Jeanne Carbonetti
Variation I on Carracci's Standing Figure
Sumi-e ink and brush on paper,
6 × 9" (16 × 23 cm), 1994. Collection of the artist.

The first finished rendition of my contour study emphasizes the single most important characteristic of a contour drawing, its continuous line. Extremely effective when drawn with sumi-e ink, a contour drawing rendered in this traditional Japanese medium gains even added strength and fluidity.

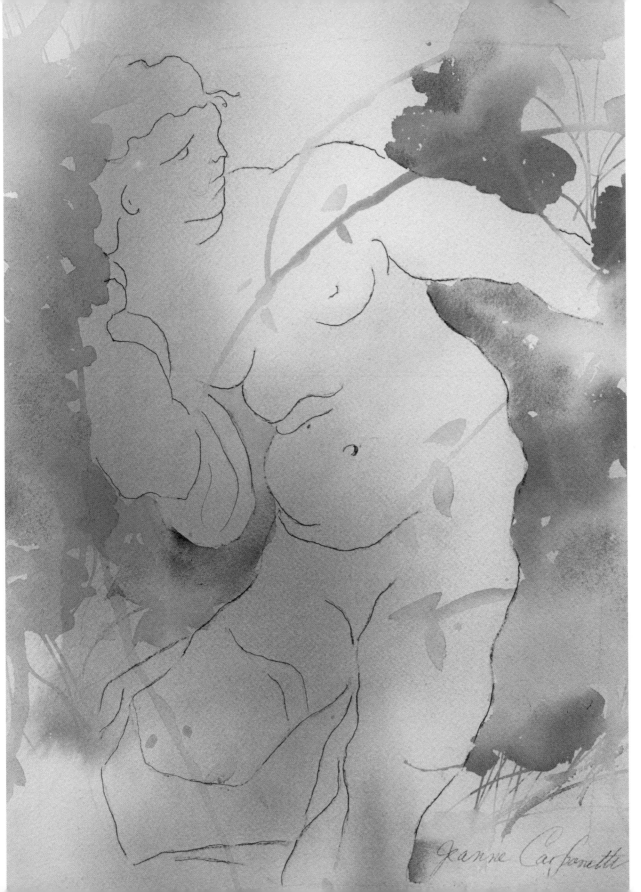

Jeanne Carbonetti
Variation II on
Carracci's Standing
Figure
Watercolor and ink
on paper, 6 × 9"
(16 × 23 cm), 1994.
Collection of the artist.

*Here, for the second
interpretation of my
contour drawing, I used
a fine ink line, further
softened by soft watercolor
washes within the figure
and slightly brighter
tones in the surrounding,
negative space to heighten
the voluptuous quality of
the female form.*

Jeanne Carbonetti
STUDY OF A HEAD
IN BRONZE
Pen and ink with wash
on paper, 11 × 8¹/₂"
(28 × 22 cm), 1984.
Collection of the artist.

*A photograph of a
sculptor's work inspired
this drawing. The focus
of the scarf and hair
attracted me in the bronze
piece, which I thought
would lend itself nicely to
a contour study with a
singular addition of color.*

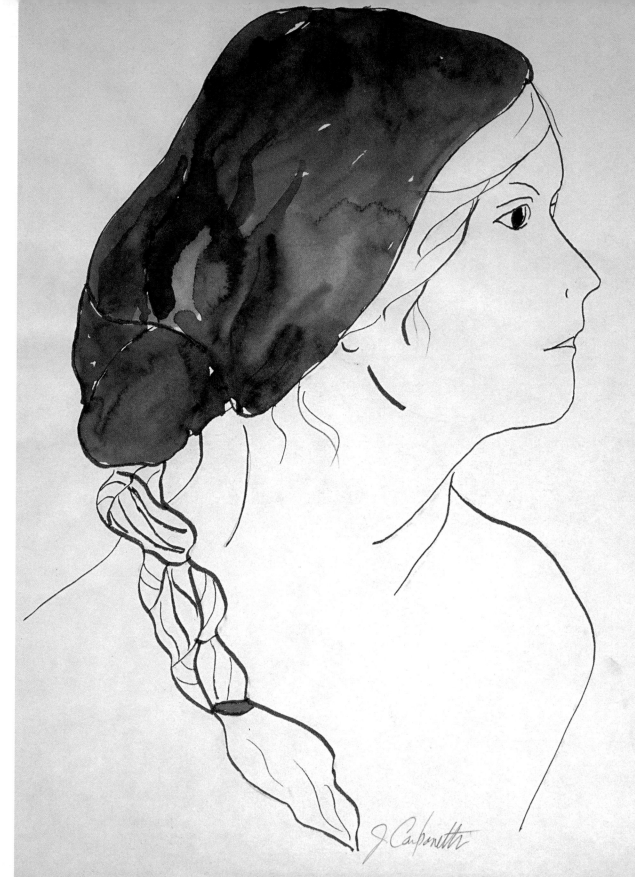

28

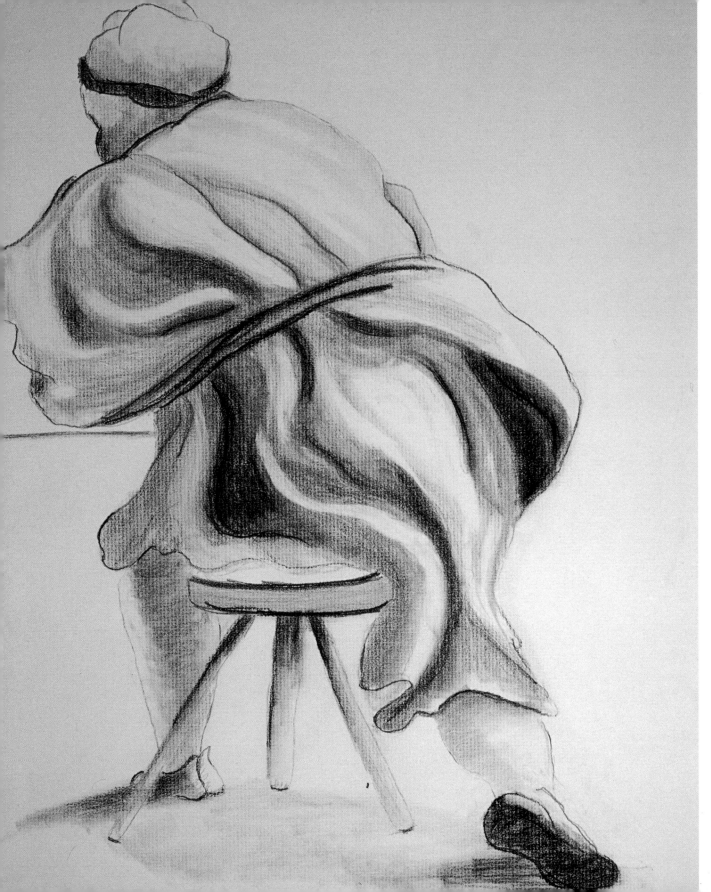

Jeanne Carbonetti
Study of
Anonymous
Fifteenth-Century
Master Drawing
Pencil on pink mat
board, 20 × 16"
(51 × 41 cm), 1998.
Collection of the
artist.

*In drawing as in life,
sometimes perceiving
is between the lines.
There was a quality
of light and a softness
to the drapery of this
old drawing that made
me want to add pink
to its light. Working
with a rubbing tool
(a stump) increased
the sense of softness,
as well. As in all my
drawings, this began
with the essential
study of gesture, then
contour.*

Feeling

Life in the heart comes when

consciousness is centered in feeling.

Hazrat Inayat Khan, Sufi Master

Jeanne Carbonetti
LILIES OF THE FIELD
Watercolor on paper,
22 × 30" (56 × 76 cm), 1991.
Collection of Bernard and Judy Stebel.

One of my favorite pieces from my "Love Series," this began as a "belly button" gesture in watercolor on dry paper. When the figures revealed their carefree essence, I finished the piece with daylilies to link them to the biblical "Consider the lilies of the field" verse.

The Practice of *Connecting*

Breathe deeply, and as you do, imagine that all the tension in your body drains out through your feet. Take a second deep breath as you imagine that all extraneous thoughts are floating weightless out the top of your head. With a third deep breath, draw your attention to your heart center. Imagine a golden translucent cord running from your heart to the heart of your subject. Through that cord, you feel all the movements of your subject. If your subject is a person, you might feel the tug of an arm upward; if your subject is a plant, you feel the flutter of its leaves; if your subject is inanimate, your feel its stillness and weight. You are able to register the slightest nuances of feeling, as energy shifts within your own body. State your intention for this drawing session: "I am one with you, and I seek to feel the wonder that is you."

There are three major ways to approach drawing: the symbolic, the visual, and the gestural. I believe that the latter is the vital link to the first two. For that reason, let us explore further the gestural first.

Gesture is the representation through some form of line of the general movement of a thing. As such, it is the core and starting place of all drawing, for it is gesture that seeks to understand the essential impulse of a subject, which then governs how all the separate parts of that subject function together. Therefore, I believe it's not only important to begin with gesture, but it's also the most natural way to begin. For in seeking to get to the core of your subject, you must approach it with your own core, using the language of your own feeling to understand the language of feeling in another, the communication between yourself and that other you seek to know.

The symbolic approach to drawing seeks to take the unique form before us and fit it into a preconceived notion we have about the way it should look. This way of seeing is characterized more by what we know than by what we see, and is much more a left-brain, thinking mind's approach to drawing. In drawing books, people, animals, places, flora, and objects of all manner are often illustrated generically to be studied and reproduced by drawing students. This way of seeing does have its value, for it simplifies a baby, a bush, a building, allowing us to understand the essence of each, which is important ultimately, but it just isn't the place to begin and certainly not to end. For what we wish to experience when we draw is not a generic representation but a particular and unique baby, bush, or building.

The visual approach to drawing is at the opposite end of the spectrum from the symbolic, in that it seeks to base anything we draw not on what we know, but rather on what we see, as a play of light and shadow. This method allows for acceptance of the form before us as a very unique form, and it is a fairly accurate way of representing subjects. But to work from only this approach is to get too specific too soon. And even if we combine symbolic and visual representation, something is still missing.

That link is the gestural approach, where you feel the thing before you as if it were being touched, getting down to its basic energetic pattern, its rhythm in space, its thrust of movement. The gestural approach is concerned with the whole package, all at once. It recognizes the heart of a thing (its spirit), traces its connection to other objects of similar essence (mind), while still being decidedly unique (body). Thus, drawing starts with the heart of the subject, and as we will see later, ends in the heart of the observer. So there is a distinct order to drawing, and it begins with gesture, the easiest way to get to the heart of it all.

Jeanne Carbonetti
QUICK CONTOUR AS GESTURE: MARTA SEATED
Marker on paper, 18 × 20" (46 × 51 cm), 1990.
Collection of the artist.

The movement from gesture into contour seems very natural to me, and I often find that doing a quick contour as a gesture helps me see only those lines that characterize the movement of the subject. Thus its goal is more gesture than contour, but it likewise begins to draw my hand and eye together in a more precise way.

Jeanne Carbonetti
QUICK CONTOUR AS GESTURE: MARTA STANDING
Marker on paper, 30 × 15" (76 × 38 cm), 1990.
Collection of the artist.

Whenever I do quick contours as gesture drawings, I like to use large sheets of paper. This enables me to really feel the line, and soon the line itself, filling much of the paper, sculpts the empty space in a way that captivates me. Then I'm ready to dive into an extended study.

33

Gestures of Form, Rhythm, and Unity

There are three major kinds of gestures: gestures of form, gestures of rhythm, and gestures of unity. Though I separate them here for your study, you will find it quite natural to incorporate a medley of them into your own gesture drawings.

Gestures of Form

Gestures of form allow your body to begin to make connection. All gestures of form seek to put the whole form within the frame of the paper within a few minutes, and they immediately give information about the movement of an object and its mass. Introductory gestures are best articulated as scribbles because this energetic form corresponds to the movement of the subject. You can move easily all over your paper as the form unfolds in mass and movement.

Jeanne Carbonetti
BELLY BUTTON
GESTURE
Watercolor on paper,
10 × 6" (25 × 16 cm),
1989. Collection of
the artist.

The belly-button gesture is my favorite scribble drawing because it starts at the very center of the form and works outward. Since the gesture moves rapidly, watercolor is a good medium for it, for it is fluid enough to allow you to move outward quickly, building the form as if it were clay.

Gestures of Rhythm

Now that you have a way of getting to know your subject in space, you will want to understand more fully what makes it tick. Now you want to go deeper inside, to connect with the rhythm of this being in space in gestures that penetrate the form, showing us its hidden curves. It is the rhythmic line of movement that establishes the direction as an impulse of energy.

Gestures of Unity

Gestures of unity are a lovely way to ease into the concentration and peacefulness of full contour drawing. Gestures of unity establish the total connection of the observer with the spirit of the thing observed, by concentrating now on the edges of the form, as if the eye that sees is feeling the form at its edges. In unifying gesture drawings, the threshold is completely crossed from the active mind that thinks and decides to the receptive mind that is one with the observed.

Exercises: The Art of the Gesture

Materials

- several sheets of newsprint or white drawing paper
- #6B pencil
- black marker

Gesture drawing, in whatever way it flows into your own rhythm of practice, provides a fluid and graceful movement from the world that separates to the world that connects.

I would like to have you experience a variety of gestures that will enable you to grasp the nature of all gesture—to get to the inside of a thing, and in so doing, establish its distinction from sketching. I cannot emphasize enough that this kind of drawing is not sketching. Understanding the difference is crucial to smooth and relaxed drawing. Gesture drawing moves you into Body Mind easily (the right-brain world of feeling and body wisdom), whereas sketching keeps you nervously hopping between Logical Mind (which judges) and Body Mind.

Exercises for gestures of form, rhythm, and unity follow. For each of these studies, have someone pose for you at four-minute intervals; you can decrease the time as you become more practiced. If no one is available to pose, use figure photos or illustrations. You might also find (at art-supply stores) books of poses for just this kind of practice.

Inexpensive newsprint is the best paper for these studies, although you might want to preserve some of your favorites on white drawing paper. Try both pencil and marker to see which gives you a sense of greatest fluidity and freedom of movement.

Belly-Button Gesture of Form. The model's body position should be somewhat exaggerated, such as twisted at the torso, so that you'll have a sense of movement to work with. Begin at the belly button and work your way out from that center in broad scribbles that follow the form outward toward its edges. Keep your eye on the figure more than on your paper. Remember, this is study to help you know—not to have something to show.

Weight-and-Mass Gesture of Form. Starting from the center of the body, as you move outward from center, concentrate on the bulk of the form, pressing harder whenever the body feels heavier or whenever it moves away from you in space and therefore becomes darker. Emphasize through heavier lines and scribbles where the body bulges (such as a buttock that spreads on the chair seat, or a midriff that bulges because of a slouch in posture). Enjoy yourself. You are beginning to "see" with feeling.

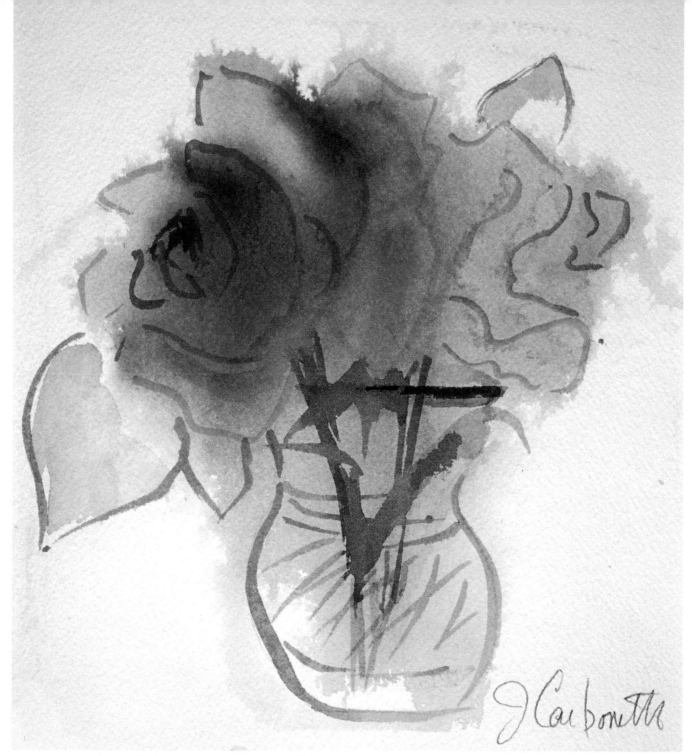

Jeanne Carbonetti
Big Roses, Little Vase
Sumi-e ink and brush with wash on paper, 6 × 5"
(16 × 13 cm), 1998. Collection of the artist.

This form gesture drawing lent itself to a spill of watercolor to accentuate the top-heavy quality of the flowers. Gesture drawings often have so much life, they become finished pieces.

Axis Gestures. In this exercise, instead of beginning at a dot in the center of the body and making many energetic scribbles, confine yourself to three lines, which indicate the major axis curve of the spine, as well as the minor axis curves of the shoulders and arms, and the hips and legs.

Memory Gesture of Rhythm. As in the previous exercise, you will be using no more than three essential lines. Look at the figure pose for sixty seconds. Then turn away. Put down in three lines or less the essence of the gesture. This is a wonderful exercise for training the eye and mind to concentrate and penetrate "reality."

Group Gesture of Rhythm. Working with two or more figures, find the line that runs through the grouping as a unit. An extension of the memory gesture, this study is good training in seeing through a subject. Do some group gestures while looking at the models, then do some as a memory, group gesture. These studies can be great fun, and while they take only a few minutes each, they train the eye-heart for a lifetime.

Zena Robinson
Woodland Path
Pen and ink on paper,
3 × 5" (10 × 13 cm),
1996. Collection of
the artist.

The gesture of unity can give you a great deal of information, and it can also help you recognize what is most important for you to convey. What became clear to Zena in this small study was the movement from thick, dense foliage to light and air.

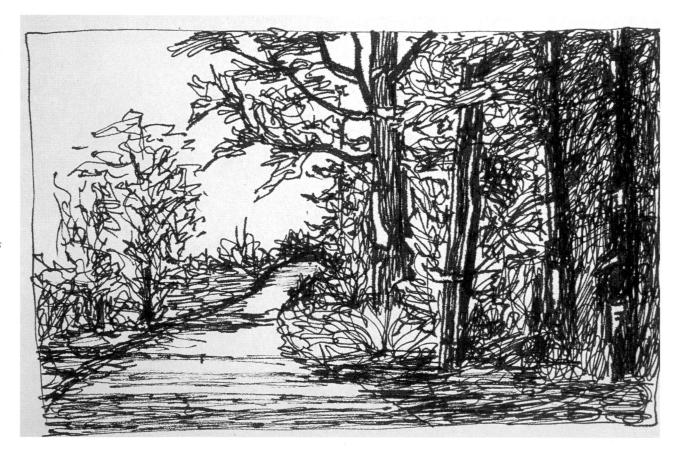

Jeanne Carbonetti
Joy
Watercolor on paper,
30 × 22" (76 × 56 cm), 1990.
Collection of the artist.

This is actually a belly-button gesture done in paint. My "Love Series," a very celebratory group of paintings, all began with gestural silhouettes. I started in the middle of white paper and worked out to the edges. When I saw what I had, I brushed a glaze of color over the form to complete the picture.

Contour Gesture of Unity. Find one edge of the figure and "hook" into it. While looking at your model, let your hand move around all the edges until you are finished. When you look down at your paper, you'll be surprised at what your hand eye has seen.

The Cross Contour Gesture of Unity. Allow five minutes for this pose. Find a starting point on the edge of the figure, and let your pencil (don't use marker for this one) follow contours *across* the body along its major forms. Allow your pencil to be lighter as the edge comes toward you (like a belly that comes forward in space), and darker as an edge recedes (such as the side of a leg that moves away from you). You don't need to do all cross contours, just those that establish the essence of the pose.

Carmen Fletcher
RELAXING WITH ATTENTION
Pencil on paper, 15 × 20" (38 × 51 cm), 1997. Collection of the artist.

Rhythm gesture drawing was designed for Carmen. Being free to shift strokes allows her to get many different textures, and it enables her to duplicate not just the feel of a thing, but its energy as well. Note how the quiet area of the cheek was smoothed and slowed by using a stump.

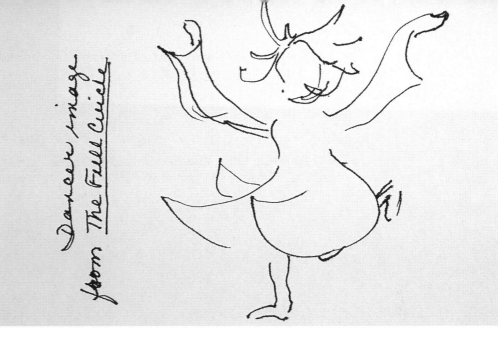

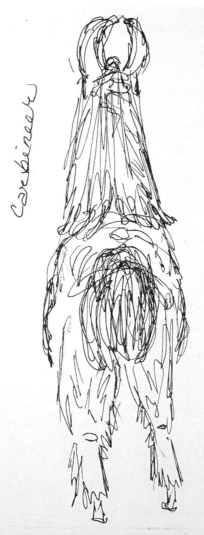

Michelle Holt
BELLY BUTTON GESTURES OF A MODEL
Pencil on paper, 11 × 8¹⁄₂" (28 × 19 cm), 1998.
Collection of the artist.

*Since it starts in the form's center and moves
outward, the belly-button gesture is worked in
the way a sculptor molds clay. This method lets
you get to know your form without the pressure
of making it look "right." Here, Michelle
includes certain stress marks in her form gesture
to express more energy of movement in those
areas.*

Zena Robinson
THE DANCER
Pen and ink on paper,
3 × 5" (10 × 13 cm), 1996.
Collection of the artist.

*This is a good example of an essential line rhythm
gesture. Only the lines that most described movement
were recorded, as in the skirt, the sleeves, the hair—
just a few lines, yet we all know she was having fun.*

Zena Robinson
FORM GESTURE OF A LLAMA
Pen and ink on paper,
11¹⁄₂ × 5" (28 × 13 cm), 1997.
Collection of the artist.

*We each have a medium that is very natural to us
and is a natural extension of our intrinsic theme. For
Zena, it is pen and ink, primarily because it clarifies
white space as full space. Notice how the llama's fur
is implied in the white space of its back and legs.*

41

Seeing

Everything is related

to everything else.

Leonardo da Vinci

Jeanne Carbonetti
First Autumn
Pastel on toned paper,
5$\frac{1}{2}$ × 7$\frac{1}{2}$" (14 × 19 cm), 1998.
Collection of the artist.

To convey a sense of those first leaves of autumn color peppering the treescape of green, I employed not only gesture drawing but also stippling, an oil painter's technique that lends a spark of energetic color to the scene.

The Practice of Honoring Mystery

f gesture drawing could be compared to the process of getting comfortable in your chair before meditation, then contour drawing would be the meditation itself.

Gesture drawing is the method by which we settle down to the task of connecting with the subject before us. By beginning with gesture drawing, we allow the left brain's interest in knowing to lead us into the process of connecting. Now, as we get to know the paper, our gesture marks, and the subject before us, our focus begins to grow stronger, and soon Logical Mind gets bored and sleepy and allows Body Mind to work, to unite and synthesize.

Approached in this way, when contour drawing follows the warmup of gesture drawing, it is a completely natural and easy transition. The contour begins to focus on the edges of the form, those edges that contain the form. The most inclusive definition, then, would be that it is a *three-dimensional* outline—not just the silhouette of a thing, but also its thickness, how the form exists in space, how the edges contain the form within and across the outside contour—like the edge indicating the swell of a belly or the protrusion of a shoulder blade. Thus contour drawing, like gesture drawing, has as much to do with touch as with sight, for our eye feels its way around the form, but where gesture drawing moves quickly and gets the whole thing at once while still seeking to know the form with thoughts and comparisons, contour drawing moves very slowly, seeking only to connect this line here to that form there.

In this way, contour drawing is not like meditation, it *is* meditation. All your consciousness comes to the same place. As your body settles down and your mind begins to concentrate, the two become one. This unity frees the spirit to connect first within yourself, creating a sense of wholeness, and then with the form out there, extending the sense of wholeness and rendering it holy.

Nancy MacKenzie
QUICK CONTOUR OF A BOY
Pen and ink on paper, 8 × 6" (20 × 16 cm), 1997.
Collection of the artist.

Pen and ink are valuable as quick contour tools because they are fluid enough to allow you to move swiftly. Here, Nancy adds special interest to the focus of the eyes by shading them rather than leaving them in contour.

Michelle Holt
Quick Contour, Landscape
Marker on paper, 11 × 8¹/₂" (28 × 22 cm), 1998.
Collection of the artist.

This quick contour also acts as a rhythm gesture. It divides up the space into its simplest components and then emphasizes the curved forms that embrace and echo the curved roof of the barn.

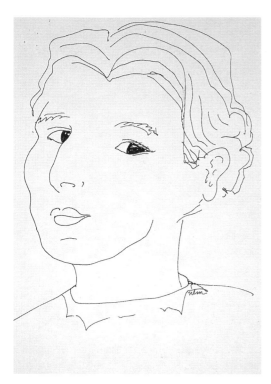

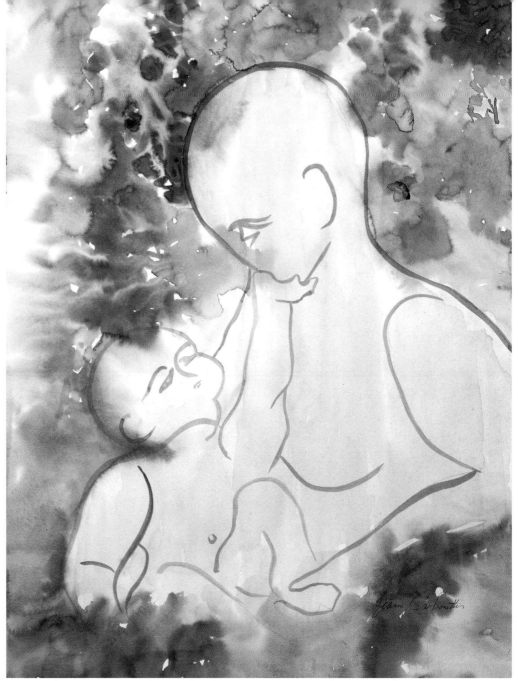

Jeanne Carbonetti
Mother and Child
Drawing in watercolor with wash,
30 × 22" (76 × 46 cm), 1987. Collection of the artist.

In this adaptation of a Mary Cassatt pose, I manipulated a contour drawing to create a more mythic theme, omitting hair to suggest stone sculpture, adding abstract flowers, and merging background and foreground to emphasize translucency.

Drawing As Meditation

I believe that by approaching drawing as a meditation, as yoga, you will learn the skill and art of drawing effortlessly. The following are some central principles.

The Consciousness of the Witness

Important to all yoga practices is the concept of the witness; one who allows what is natural to come about in its perfect time and way. We don't make a leg flex beyond its capabilities; that would only produce a strain and reaction of greater tightness. We let the leg feel comfortable in an easy stretch and when the body knows it's safe, it eases quite naturally into more and more flexibility. Likewise in contour drawing, we don't manufacture an image; we allow it to unfold.

The Gift of the Present Moment

Yoga postures require balance, and unless you concentrate fully on a posture, it's unlikely that you'll be able to hold it long enough to gain benefit from the stretch. The same need to be fully focused is true in drawing, which is why it's critical to keep your eye on your subject, not on your paper. Avoid checking or trying to fix anything while doing contour drawing. Particularly in drawing the figure, if you follow one contour of a muscle to its end, then begin with a new edge as the next muscle begins, it will tell a more powerful story than one line that slides over both.

The Feeling of Energy

Important to the practice of yoga is the ability to feel energy moving in your body—physical sensations such as tingling, buzzing, aching. In Eastern arts, this is known as feeling your *chi,* and as your unity of body, mind, and spirit develops, chi will flow. Experiencing that energy in drawing is also quite a revelation. It enables us to depict a three-dimensional, solid form in real space, as opposed to a diagram or flat, two-dimensional outline. It's the difference between flying over a mountain versus climbing it. We feel the energy of moving up and across, the jaggedness here, the smoothness there, and each of those feelings makes an impression on the line that defines them. True seeing is *feeling* activity.

The Fullness of Empty Space

One of my favorite principles in yoga is that of the Wu-Wei, the idea that space is not empty, but full, because energy is not just in us, it's outside of us, and the two streams flow back and forth ceaselessly. Keeping the flow is the reason for doing yoga. When the flow stops, uneasiness—a form of dis-ease—occurs. This concept relates to drawing, as the fullness of

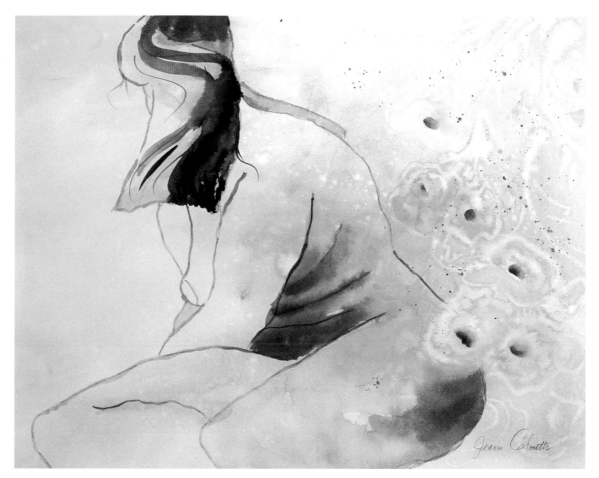

Jeanne Carbonetti
MODEL SITTING ON FLOOR
Sumi-e ink and wash on toned
paper, 22 × 30" (56 × 76 cm), 1990.
Collection of the artist.

*This was originally a quick contour
drawing, but I transferred it to
watercolor paper tinted with wash
because I liked the way the figure
sat on the page and how the positive
and negative spaces interacted.*

space energizes a figure or form within it and the space around it. When we draw, recognizing the shape of a space can quickly give us important information about our contour. The very shape of the space at the edges of the paper impacts on whether we see "real space," in which something three-dimensional can exist, or "symbolic space," which doesn't have depth.

All Things Are Related

If you remember only one statement out of all the text in this book, I hope it will be Leonardo da Vinci's words at the beginning of this chapter: "Everything is related to everything else." In yoga , it's quite obvious, for you do not affect one part of your body without feeling the rippling effect of that impact through your entire system. If I tense my shoulders in the same posture for too long as I write, I feel it not just in my shoulders, but down my back, on my neck, even in my ears. The same principle applies to drawing. When we drew a box around the form in our first exercise, it gave us a frame of reference for horizontal and vertical lines in the box, allowing us to see one shape in relation to all others around it, whether positive shapes—those of the form—or negative shapes—those of the space around the form.

Exercise: The Art of the Contour

Materials

- photo of a figure
- board to hold paper
- 1 sheet of 16 × 20" white drawing paper
- 2 sheets 16 × 20" tracing paper
- #6B pencil
- marker pen

The wisdom to be gleaned from contour drawing is that your energy follows your attention. When you shift your mind's focus, you scatter your energy. If you repair as you go along to speed up the process, moving out of Body Mind and back into judgmental Logical Mind, you break your connection to your subject, and usually have major proportional corrections to make at the end. Instead, trust that your body and mind can work together, and enjoy the dance, as outlined in the exercise that follows.

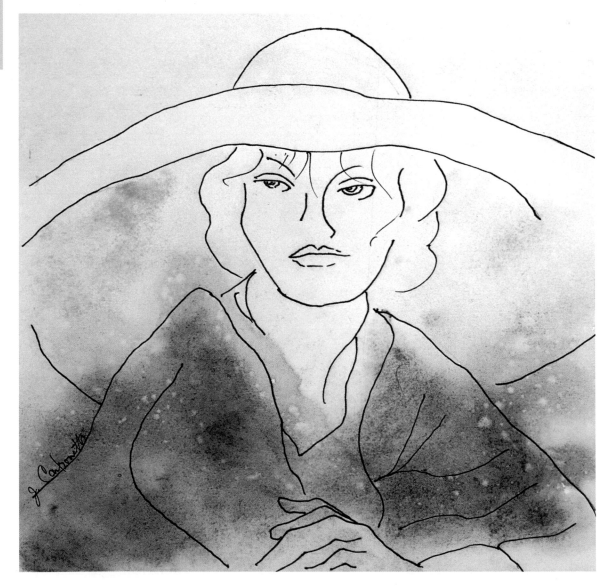

Jeanne Carbonetti
GIRL IN A BIG HAT
Pen and ink with wash on toned paper, 8 × 8" (20 × 20 cm), 1998. Collection of the artist.

I love the energy of big, encompassing shapes, be it an individual form or a grouping.

48

Appropriate thirty to forty-five minutes of uninterrupted time for this exercise, in which you will create a figure drawing in contour, including both outside and inside contours. This exercise reinforces the ones you did earlier; use the illustrated example (page 25) for reference. After you've finished, follow the same procedure to create a contour drawing of an object, an interior view, or a landscape vignette.

Step 1: Attach white drawing paper to your board, then mount both sheets of tracing paper over it.

Step 2: Make a box on your top sheet of tracing paper to contain your form. To guide proportions, put a mark at the halfway point on each side of the box.

Step 3: Get to know your figure by using a scribble gesture for mass and volume, starting at the belly and working outward with the side of your pencil in energetic circles and curves. Press hard along the shoulders, spine, and hips to articulate the body's movement. Within ten minutes, you should know your form well and be ready to proceed to your contour drawing.

Step 4: Remove the gesture drawing. On your next sheet of tracing paper, prepare a box for your contour drawing. Close your eyes, breathe deeply, and center yourself by observing your breath. Eyes open now, choose a point on the figure's outline and with your pencil at the corresponding spot on your paper, draw very slowly while looking mostly at your figure. Whenever you come to a natural juncture point, such as a change of direction, don't lift your pencil; keep it on your paper. *Do not erase!* Instead, if you need to move your line, simply make another over it. Also, don't go back and forth over your line; allow it to be one smooth flow. Continue in this way until your contour drawing is complete. Now you may use an eraser to polish your line.

Step 5: Go over your penciled contour with your marker. Then, on the reverse side of the tissue, trace that marker outline with your pencil. Turn the sheet face up again and transfer your drawing to the white paper beneath by going over your marker contour line once again with pencil. As you do so, the carbon of the pencil on the reverse side will transfer to your drawing paper. Once that is accomplished, you're ready to finalize the work by going over it with your marking pen to create your finished contour drawing.

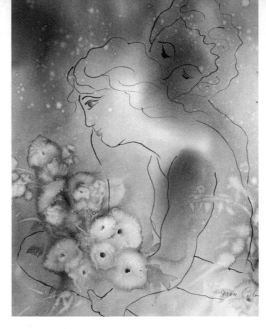

Jeanne Carbonetti
STUDY FOR TWIN FLAME
Marker with wash on toned paper, 25 × 22" (64 × 56 cm), 1990. Collection of the artist.

When does drawing stop and painting begin? Is the story told by line (drawing) or tonal value and texture (painting)? This story is told in line, with painterly touches in its flowers.

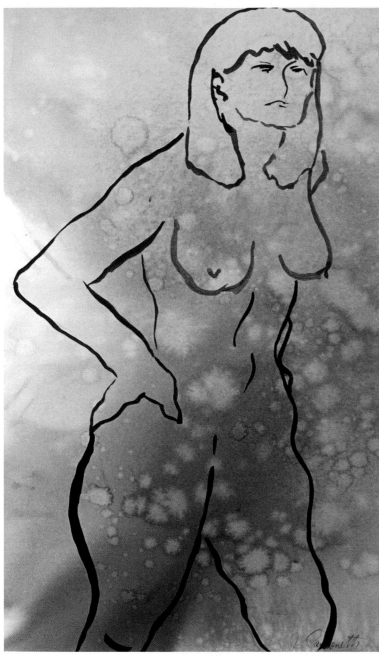

Jeanne Carbonetti
STUDY FOR SONG OF EVE
Sumi-e ink and wash on toned paper,
20 × 15" (51 × 38 cm), 1990. Collection of the artist.

As a watercolorist, I am drawn to contour drawing, the creation of shape out of empty space being akin to the transparency of watercolor.

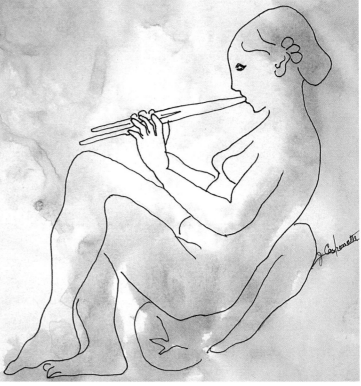

Jeanne Carbonetti
STUDY OF A STONE FLUTE PLAYER
Pen and ink with wash on paper,
10 × 19" (25 × 23 cm), 1998. Collection of the artist.

This sweet little stone flute player with a flower in her hair seemed perfectly suited to delicate ink and wash, itself classical in nature.

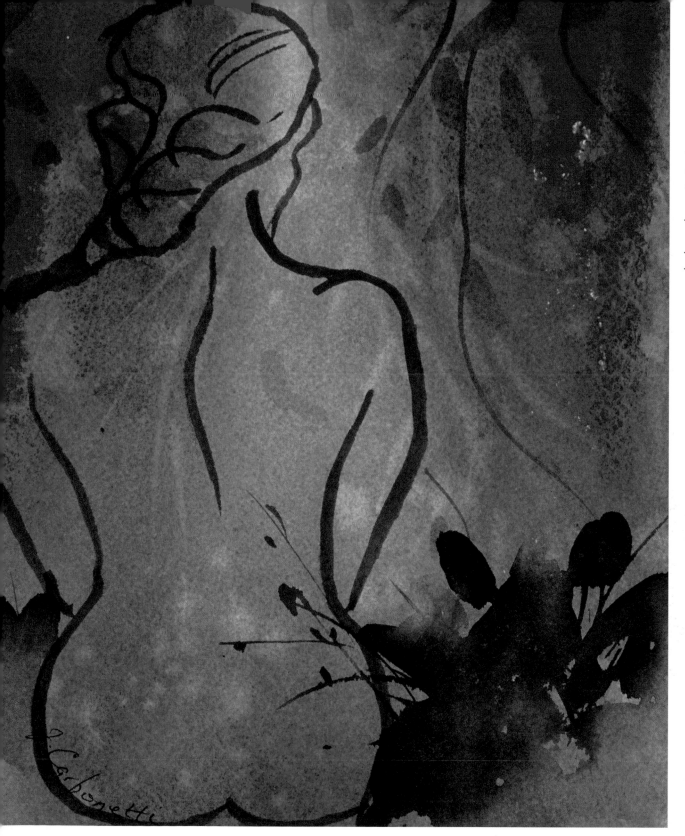

Jeanne Carbonetti
GIRL IN ORANGE SUNSET
Sumi-e ink and brush on
toned paper, 6 × 5"
(16 × 13 cm), 1997.
Collection of the artist.

*A scrap of an old watercolor
painting seemed a good
ground for a contour
demonstration. When I
finished the figure, the mood
was so distinctive, it called
for the additional bits of
foliage to create real space.*

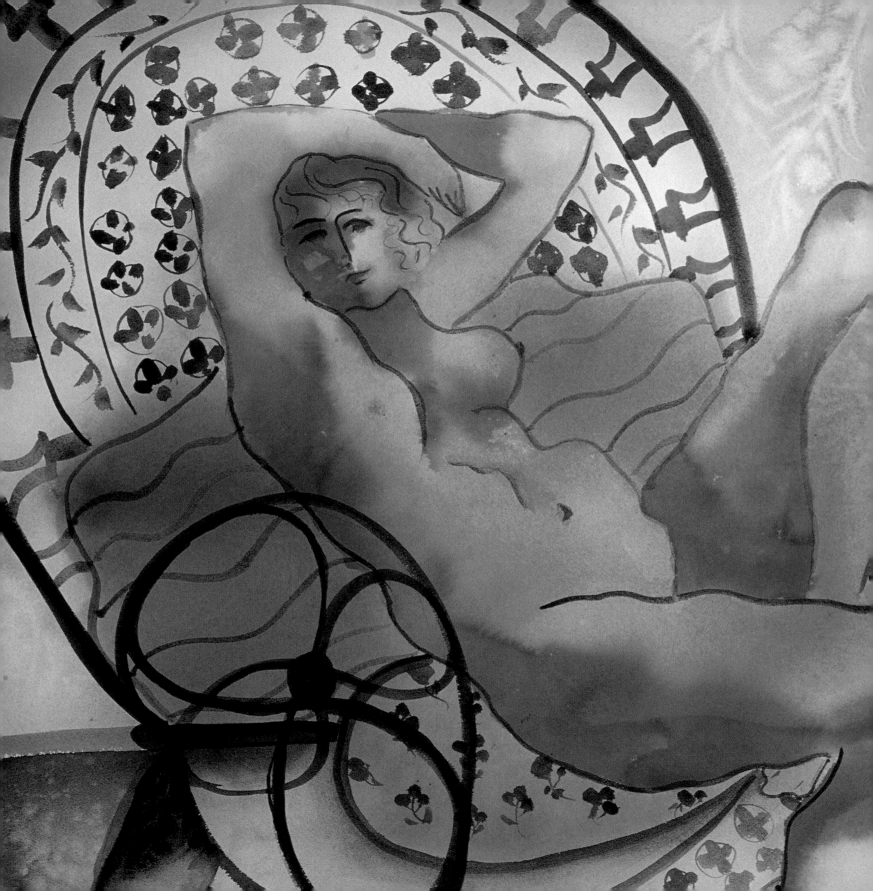

Touching

Someday perhaps

the inner light

will shine forth from us,

and then we shall

need no other light.

Johann Wolfgang von Goethe

Jeanne Carbonetti
STUDY OF MATISSE'S LADY
Sumi-e ink and watercolor on paper,
22 × 25" (56 × 64 cm), 1998.
Collection of the artist.

This began as a demonstration in class to illustrate different kinds of shadows. Then I went home and played with space around the figure, added a warm orange wash to complement the cool blue background and to balance the vitality of the chair with added color energy.

The Practice of Holding

Close your eyes and breathe deeply. Feel any tension drain through your feet. Breathe deeply again and feel your scattered thoughts of judgment float out the top of your head. With another deep breath, let everything go. Let your intention to be one with your subject draw the attention in your eyes and hands together. They link, now ready to embrace the subject you see. They will touch it and feel its weight. Your whole body joins them now, feeling the whole gesture of this unique subject. Your mind is with it, free of judgment and fear. Your body is with it, ready to feel. Your spirit is open to it, ready to learn. Now open your eyes and begin.

Just as receiving, feeling, and seeing are integral to recording the gesture and contour of a subject, the perception of holding gives the viewer another level of valuable information: how it relates to the form's volume, how it exists in space. Form is revealed by tonal values—lightness and darkness. Together, they describe an object's volume, its mass, density, weight, texture, and even its mood.

Studying the value range of your subject, its pattern of lights and shadows, gives you both optical and sculptural information. The optical aspect relates to how a form moves out from its center in space. The sculptural aspect tells you about your subject's three-dimensionality, giving you a kinesthetic sense of touching your subject and its texture and mass.

As a yogic kind of meditation then, let's examine the three major principles—unity, inner feeling/outer form, and subjective mood—revealed by the study of shading. These unify not only your own body, mind, and spirit, but also your union with the essence of your subject.

The Principle of Unity

A study of tonal shading, or the lights and shadows of a form in space, can help you develop the capacity to see patterns in a form. This is one of the most delightful ways to get to the more intimate, essential qualities of your subject. Interestingly, while it begins in the details of shadow and light, it moves quickly to the summary of these energies, and this unity is not the absence of detail, but the movement through complexity to the *essential* detail that reveals the form.

The Principle of Inner Feeling/Outer Form

Light and shade reveal not just the lightness or heaviness of your subject in a technical way; they also reveal the mood of the subject's inner life. What something is on the inside affects, in some way, how it looks on the outside. This is particularly easy to see in figure drawing, but it applies to inanimate objects as well. Even an apple is different from another apple because it has grown in a different way. Some apples have broad shoulders, others have big bellies.

The Principle of Subjective Mood

The application of shading in drawing is also affected by the viewer's own mood. This is an intrinsic part of the story, because my mood will cause me to see and draw that apple through a slightly different filter from yours in viewing and drawing the very same apple. The lesson here is a classic one: Art is always a mirror; that's why it's so powerful. It always speaks not just about what's out there, in the subject; it also speaks about what's in here, in the artist.

Volume and *Value*

The art of shading is developed by learning to recognize volume as represented by the pattern of light, medium, and dark values of the subject before you. Once you've acquainted yourself with patterns of light, you will have a framework for rendering the subtleties of shading. These include:

- *Highlight.* The most concentrated spot of light on your subject and the lightest spot, highlights appear on particularly smooth surfaces. Keep in mind the value range of the form beneath the highlight, so that the highlight doesn't appear to be pasted on.
- *Local tone.* The most general value of the subject, whether basically light, medium, or dark (such as a white shirt, medium tie, dark jacket), is its local tone, or value, made up of a halftone (middle range of value of the subject), and it can also include a quartertone (transitional value from the lightest to the medium value).

Carmen Fletcher
MY CAT
Pen and ink with wash on paper,
11 × 15" (28 × 38 cm), 1997.
Collection of the artist.

This is a lovely use of essential line and the expression of volume through simple value changes in wash.

- *Reflected Light.* Light that bounces off another object and comes back to your form reveals the form—but it may confuse it, by taking away from the understandable pattern of shadow already formed, so it has to be considered carefully. Also be mindful of the fact that reflected light may appear strong, but it needs to be weaker than the highlight on your subject.

- *Cast Shadow.* Produced by an opaque object that gets in the way of a light source, a cast shadow might be made, for example, by a hat on a person's head throwing a shadow across the face. While a cast shadow can reveal form, it can also hide form, but it can still have its own dynamic, mood-projecting energy.
- *Structural Shadow.* Intrinsic to the form, on the human figure, for example, structural shadows include the eye socket, the philtrum (vertical groove over upper lip), part of the neck under the chin, and so on. Even if a light were shining directly on those areas, they would need a shadow to define them and show their structural integrity.
- *Form Shadow.* Produced when a form turns away from its light source, form shadows are what we generally think of as the shadowed side of a form. For example, if the light source is on the front of the face, the side will be in shadow. If the light is moved to the side directly, the front will now be in shadow because there has been a plane change from the light source.

Jeanne Carbonetti
SEATED MODEL WITH TOWEL
Pencil and watercolor on paper,
13 × 7" (33 × 18 cm), 1990.
Collection of the artist.

This work is just shy of being a painting, but it hasn't crossed that threshold yet, because my watercolor is used more or less to fill in shading between the lines.

The Art of Shading

Materials

- an apple
- cloth napkin
- #3B (soft) pencil
- #3H (hard) pencil
- white drawing paper
- tortillon (pointed blender, made of paper: optional)

There is so much to take in when looking at subject matter when you draw it, it's important to establish an order for seeing and receiving information about your subject. The most natural way to build a drawing is from the general to the specific—to see and record the overall structure before getting down to its details. That approach also applies to the art of shading.

Even with an object as simple as an apple, you must decide the order in which to build the pattern of lights and darks that it presents. So allow yourself time to see that pattern, before picking up your pencil.

Jeanne Carbonetti
STUDY OF A MICHELANGELO
KNEELING DRAPED FIGURE
Pencil on pastel paper, 14 × 8"
(36 × 20 cm), 1992.
Collection of the artist.

As a watercolorist, I'm particularly partial to fluid passages. Whenever I do a full shadowed rendering, a tortillon gives me that sense of fluidity as it helps me to blend one value into the next in a manner reminiscent of watercolor. This technique is particularly useful in capturing the folds of cloth.

Step 1: Drape a cloth napkin casually on a table, then place an apple on it, so that it's surrounded by many folds. Now relax and just look. Give yourself time to see the pattern of shadows and lights produced by those folds, the contours of the apple, and the shadow that the apple casts on the cloth. As in our previous studies, begin with gesture, letting your pencil strokes flow freely. From gesture, work your way to contour.

Step 2: Take whichever pencil, soft or hard, instinctively feels best, and begin by getting down what you see as the local tone—the value that is most general to the apple and to the cloth. Then, if you would like a soft, diffused quality, use a tortillon to blend.

Step 3: Let the patterns of light, medium, and dark values speak to you as you work. Look for structural shadows, form shadows, cast shadows, reflected light, and highlights, in that order.

Michelle Holt
Two Roses
Pencil on paper, 15 × 6"
(48 × 16 cm), 1998.
Collection of the artist.

Michelle found that the meditative quality of moving from gesture to contour to shading gave her love of detail a new dimension. Here, she began to view space itself as full and as valuable as the drawn line. A beautiful balance of form and space emerged naturally.

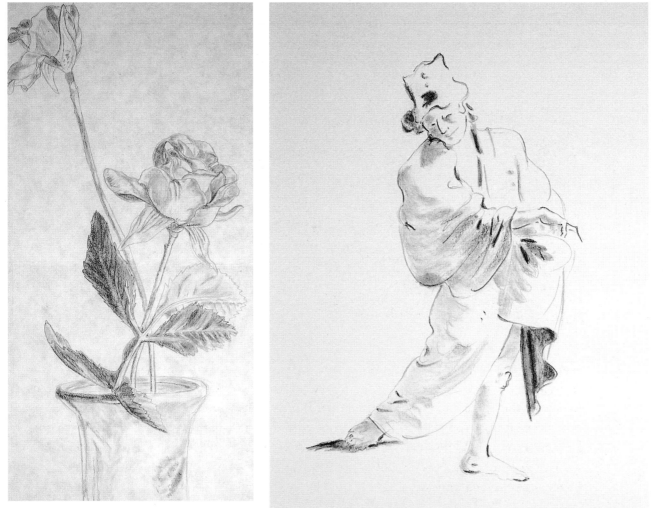

Elizabeth Gardiner
Study of Tiepolo
Pencil on paper,
11 × 8 1/2"
(28 × 21 cm), 1998.
Collection of the artist.

Although the Tiepolo work that inspired this study included a wash to indicate shadows of the sleeve and gown, Elizabeth chose to translate those areas with pencil, for it made even clearer the process by which the master chose certain areas to highlight.

Zena Robinson
GARDEN AT GIVERNY
Pen and ink on paper,
8 × 6" (20 × 16 cm), 1996.
Collection of the artist.

Very important to the art of shading is finding the pattern of lights and darks. Here, Zena has clarified what might have been a confusing array of shapes and tonal values by simplifying her lights, mediums, and darks into well-defined, connected areas.

Step 4: Put your drawing down on the floor at some distance from you. Get up and stretch, then come back to look with fresh eyes. What do you see now that you might adjust to render the apple and the cloth more truthfully? This will naturally aid your first seeing next time around, so be accepting of it, not critical. And what do you see of your own pencil strokes? How would you describe them? How did you vary your strokes as you went along? Recognizing this will be a clue to your own special and unique vision, which is always a part of the art of seeing and drawing.

Jeanne Carbonetti
CHRISTMAS ANGEL
Pencil on paper, 6 × 6" (16 × 16 cm), 1995.
Collection of the artist.

*Although I'm partial to the empty space of
contour drawing, there are moments when only
full shading will do. This was the case when
I saw this angel carved in wood. Its wings were
a joy to sculpt with pencil.*

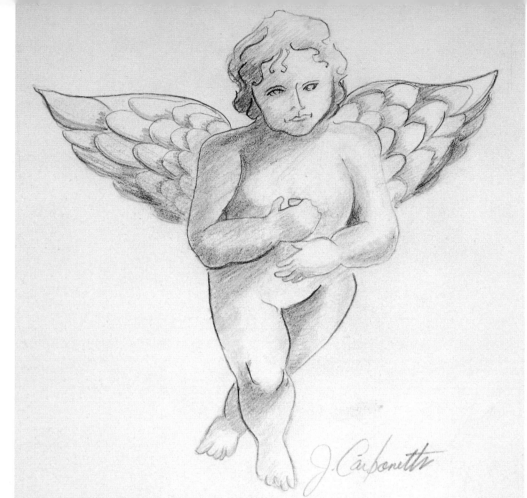

Shirley Mission
ABSTRACT WITH TONAL VALUES
Pencil on paper,
14 × 22" (36 × 59 cm), 1998.
Collection of the artist.

*There is nothing like a "scribble"
picture to illustrate how shading
can sculpt space to volume. Shirley
started with a simple outline, which
she filled in with a graduated range
of tonal values.*

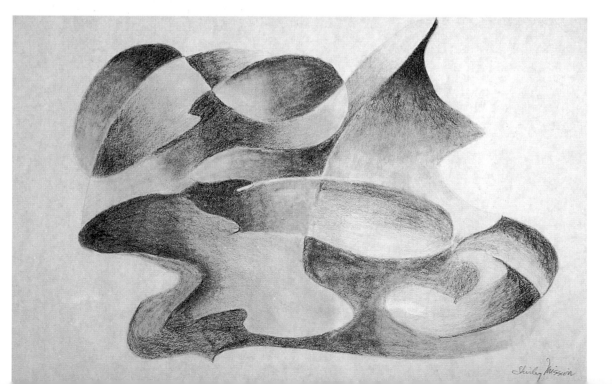

60

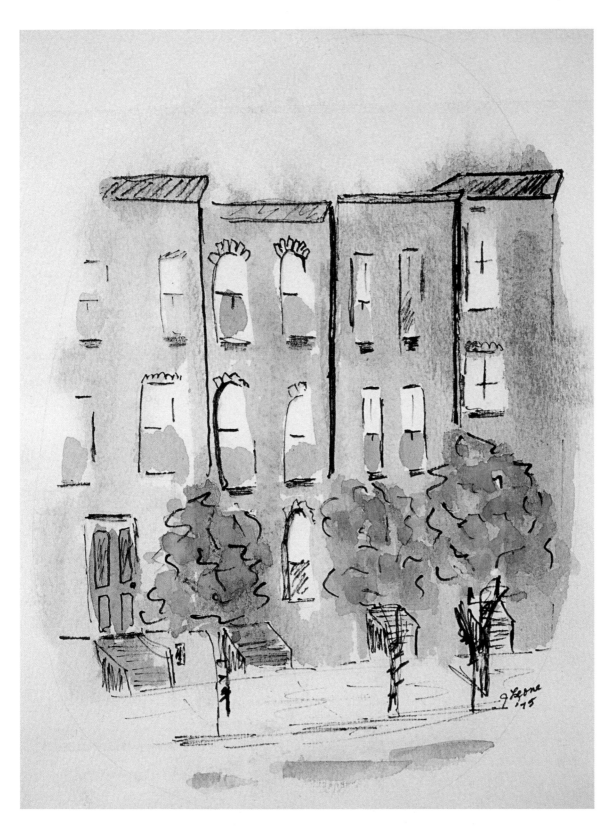

Jeanne Carbonetti
GREENWICH VILLAGE
Pen and ink with watercolor on
paper, 8 × 6" (20 × 16 cm), 1975
Collection of the artist.

*To capture the mood of this quaint
neighborhood, I thought a pale wash
best expressed the scene's local tone, or
value. This seemed to add the touch
of sweetness that pencil or pen alone
would not render.*

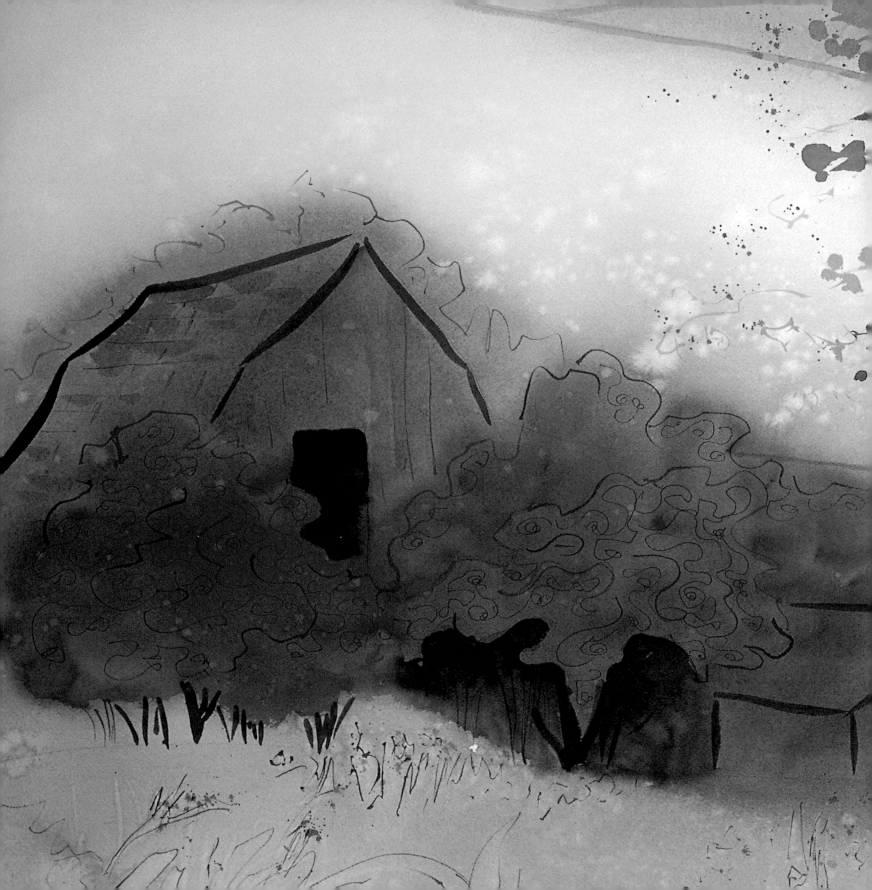

Simplifying

Behind the many, the one.

Vedic Scriptures

Jeanne Carbonetti
BARNS IN LANDSCAPE
Sumi-e ink and pen with wash on
paper, 22 × 30" (56 × 76 cm), 1998.
Collection of the artist.

*This was a demonstration piece on
simplifying. Each component was a
piece of the jigsaw puzzle. Additional
marks within the shapes were made
very carefully so as not to overdo. The
extra flourish in the trees around the
barn seemed necessary, however, to add
some excitement to the focus.*

The Practice of *Unifying*

Take three deep breaths, and release all tensions in your body, your mind, and your spirit. Call your power back into your center, just below your navel. You are perfectly balanced now.

Imagine that at your will, you can change the magnifying power of your eyes from normal to very large to focus on small details, then to very small to focus on large patterns. Imagine that you can move back and forth fluidly, always seeing a complete picture. Now state your intention: Let me be one with essence.

The great gift of your mind is to see beneath layers to truth at its core. In its most powerful aspect, your mind simplifies and unifies, gathering and sorting all the data until there is recognition of the pattern that motivates the life force of the things you observe. It is your mind's ability to find implicit order behind seeming chaos.

But for your mind to give you this great gift, you must give it proper time, not tax it too early. Artists who practice sumi-e, the great tradition of Japanese brush painting, understand this principle of going through all the details to get to the essence. This is perhaps the greatest lesson of yoga, as well. When we allow the proper order of body and mind, a profound and lovely result occurs. Mind yields its outer layer of detail gatherer to the more powerful and quiet layer of simplifier, where unified relationships emerge as patterns of meaning. This is the principle that makes the order of gesture drawing to contour drawing so graceful.

For those who find drawing at best tedious or at worst exasperating, I believe the antidote is this simple change in the order in which each consciousness is applied. The problem arises when one tries to simplify too soon, asking mind to begin before it is time, which results in a rendering of the stick-figure person or the lollipop tree as symbols for the authentic object.

When the time is right, your mind will give you its perfect gift. In drawing, this means that you'll begin to recognize patterns of proportion, of curves, of junctures, and of rhythms—without focusing on too many details, but on the essential detail, rendered not as a simplistic symbol but as a true summary. Then you will move from the generic rose to the specific rose you see. When this threshold is crossed, a new level of understanding and seeing begins.

Patterns

Relationship patterns govern structure throughout nature. The human figure grows with the same perfection of proportion as a seashell, a fern, a rabbit, or myriad other of nature's treasures. Nature brings harmony in developing its harvest, uniting the different parts of a whole and at the same time, allowing each part to maintain its identity.

While it's useful to the artist to recognize patterns of proportion in drawing trees, flowers, and other objects, it's essential to have an understanding of natural proportions when drawing the figure. Leonardo da Vinci's famous Canon of Proportion has guided sculptors and artists through the centuries. It establishes the perfect adult body length as six times the length of the head. Another method is to think of the human figure as a series of rectangles: the head as one, the trunk as two, with three making up the legs. The ratios that pertain to each of our limbs and digits, from joint to joint, also follow beautifully balanced patterns. Thus, there is a lovely and simple order behind the complexity of human growth, and knowing it makes it easier to check your drawings for accurate proportions.

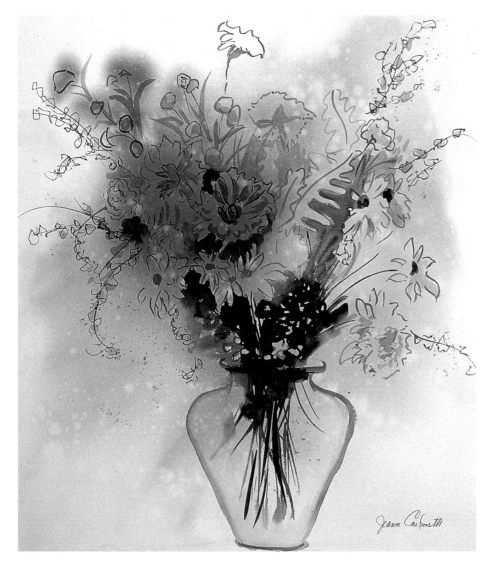

Jeanne Carbonetti
DINING TABLE STILL LIFE
Sumi-e ink and brush on toned paper,
25 × 20 (64 × 51 cm), 1998.
Collection of the artist.

Masses are simplified into an essential shape and focus to render a readable drawing of flowers in this still life. I think of this technique as "clumping," and it requires patient practice. I joke with my students that when we get to drawing flowers and landscape, they'll long for the simplicity of drawing figures.

When a figure is in a position other than standing, it may seem more difficult to judge and draw correct body proportions. Students often fill in parts of the trunk or legs of a crouching person as if he were standing up. This is a case of drawing what we know and not what we see. The crouching person with head down may well be hiding his trunk area completely. If you recognize that two heads' worth of trunk area are not showing, it will help you to draw the correct structure. Another aspect of figure proportion relates to major and minor axis lines. The major vertical axis line is from the nose through the spine; horizontal axis lines cross the body at the eye, shoulders, breasts, hips, and knees.

The ability to simplify rhythmic ratios in figures and throughout nature into meaningful patterns amplifies an essential detail into something wider than itself. The most important thing to remember is that with time and patience, patterns of relationship will emerge.

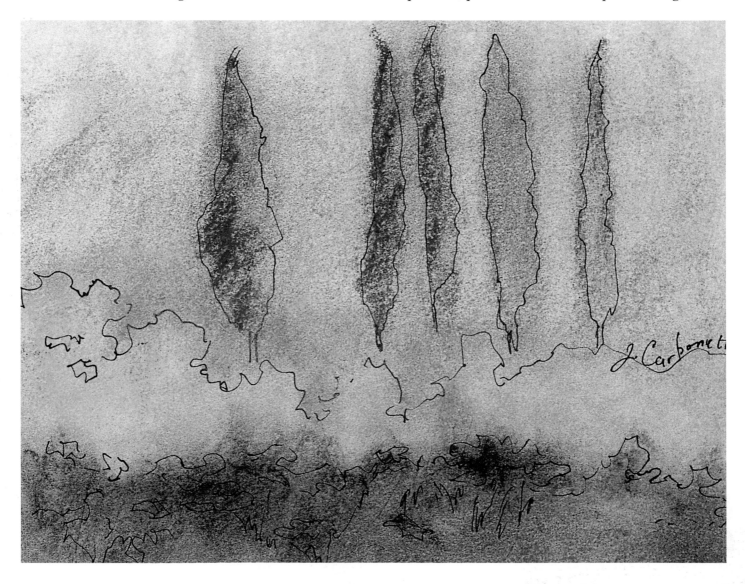

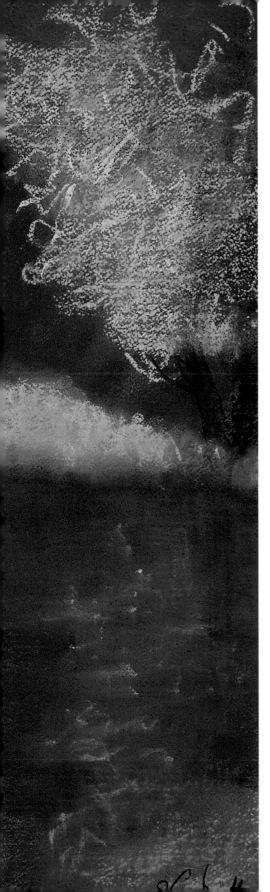

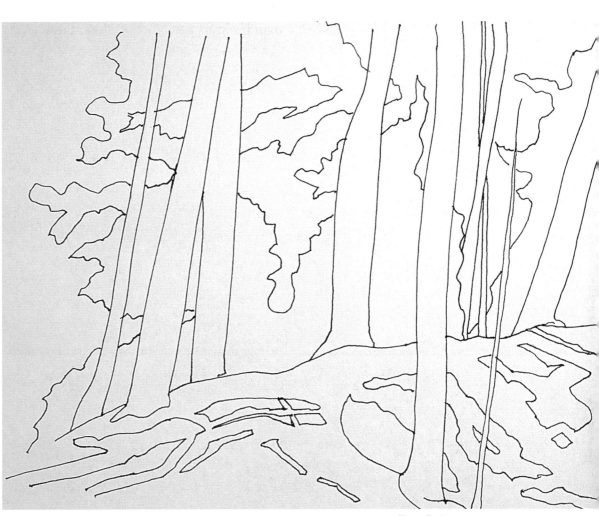

Zena Robinson
Treescape, Island Pond
Pen and ink on paper, 7 × 10" (18 × 25 cm),
1998. Collection of the artist.

This drawing is an excellent example of the art of simplifying, where Zena used contour drawing to signify the pattern of trees and also to establish a lively sense of perspective.

Jeanne Carbonetti
Autumn on Thetford Pond
Pastel on toned paper, 5 × 16" (13 × 41 cm),
1998. Collection of the artist.

Simplifying means not only leaving something out, but also pushing something to its more intrinsic shape or color. In this scene, there was much more activity in both shape and color on the pond, but it seemed necessary for the easy reading of it to create both summary colors and shapes.

67

Exercise: The Art of Rhythm

Materials

- #3B pencil
- 2 sheets of tracing paper
- white or pastel paper
- marker in color of your choice

So what does rhythm have to do with simplifying? Rhythm orders things, communicating the hierarchy of importance that the artist assigns to various elements in a drawing. In the ever-widening movement from body to mind, the artist goes from a more intimate partnership with the subject to a wider scope that includes the possibility of another viewer as well. The question becomes: How do I express myself in this drawing so that others can see what I see? The answer may be found in the following exercise, designed to bring clarity and unity to a drawing by simplifying the lines, values, textures, and space that convey both structural and organizational information. Some steps will be familiar to you, as they are based on, and reinforce, our initial exercise (see page 24).

Sit outdoors, if possible, and devote a half-hour to this landscape study. Working indoors and viewing landscape through a window will also do nicely. But it's best *not* to use an illustration or photo, because too much simplification will have been established there already.

Step 1: As in earlier studies, anchor both sheets of tracing over your drawing paper, then pencil a box around the top sheet to "frame" your picture. Begin your gesture drawing of the overall shape of your landscape. Soon you'll gain a sense of the general thrust of several forms coming together.

Carmen Fletcher
BASKET AND GOURDS
Pencil and charcoal pencil on paper,
15 × 22" (38 × 56 cm), 1997.
Collection of the artist.

The strong compositional blocking of this piece gives it its power. The black band across the back holds the piece steady while the white space becomes very important full space.

Jane Philpin
STUDY OF DA VINCI DRAPERY
Pencil on paper,
22 × 15" (56 × 38 cm), 1998.
Collection of the artist.

Drapery, like still life, is a subject that can strengthen your ability to simplify. In this study, Jane took a while to sit with Leonardo da Vinci's drawing until the largest folds became prominent. Then it was easier to proceed.

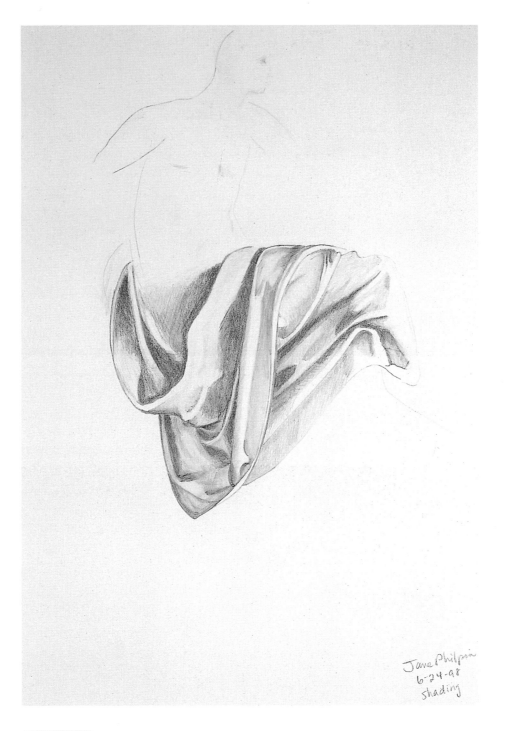

Step 2: Take your time, noting what impresses you, and let the gesture emerge. These impressions will start to coalesce into a regular rhythm as you look for the intrinsic shapeliness of major landscape forms: the horizontality of hills, the ovalness of maple trees, the verticality of poplars.

Step 3: Remove the top sheet of tracing paper and draw a box on your second sheet to frame your contour drawing. Begin simply with the most obvious lines and shapes. Step back and study your drawing. Are your contour lines well placed within your box? Are your shapes and spaces balanced? Is there a sense of movement yet, either directional, as in back to front— or descriptive, such as fast, slow, or angular?

Marilyn Clough
VALUE STUDY OF A STILL LIFE
Watercolor on paper,
11 × 15" (28 × 38 cm), 1998.
Collection of the artist.

In this little watercolor study, Marilyn simplified its broadest components, which enabled her to prioritize clusters of subject matter from most detail to least detail.

Step 4: When you like what you see, go over your pencil contour with a marker, then transfer it to drawing paper in the manner described earlier. With your basic lines on your good paper, fill in your drawing, but be careful not to add too much detail. Make up your own calligraphy to describe movement. An excellent source of inspiration for this is any drawing by Vincent Van Gogh, a master at utilizing different kinds of marks to calibrate rhythm.

Step 5: When you've finished, step far back to see if your drawing has unity, a strong focus, and if your travel path is clear to the viewer's eye.

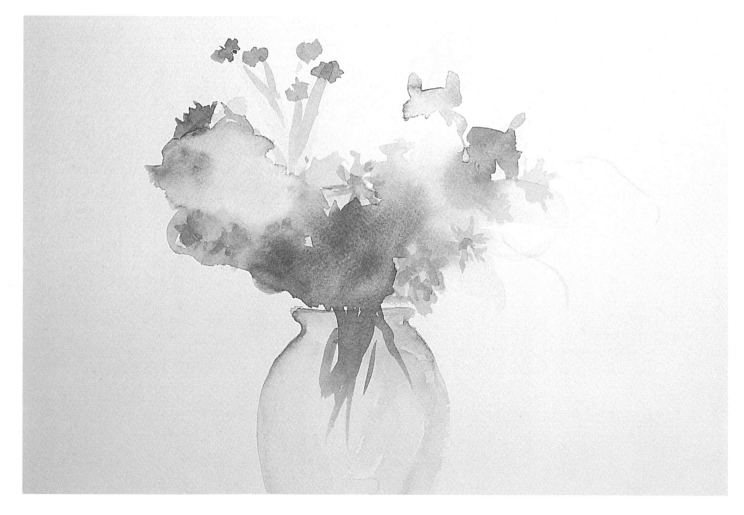

70

Jeanne Carbonetti
SAMANTHA
Pencil with watercolor on paper,
7 × 5" (18 × 13 cm), 1998. Collection of Ann Leone

A photograph I had of my niece Samantha was a lovely mix of blue hat, pink jacket, and yellow roses. But that was too much color for a drawing, so I decided to eliminate all but yellow, thus emphasizing the roses, and I rendered the jacket only in contour rather than full shadow in order to balance this decision.

Alexis Kyriak
TREE, WEEPING
Pastel on paper, 22 × 15" (56 × 38 cm), 1997.
Collection of the artist.

Like parables and proverbs, the simplest drawings are often the most powerful and profound. They are also the most difficult to execute, precisely because every part has to carry so much weight. The blocking of the white and yellow sections of this background provide a sense of fluctuating atmosphere, while the green shrub at left complements the red trunk at right and anchors the piece.

Choosing

We are the sum total of our choices,

which define us.

Woody Allen

Jeanne Carbonetti
Two Jars
Pastel on toned paper,
8 × 9" (20 × 23 cm), 1998.
Collection of the artist.

*The element of texture has much to do
with the sensation of touch, not just for the
feel of a thing itself, but also for the feel
of the space around it. Here I wanted the
background space to enclose and compress
the space around the jars, so I specifically
chose shapes of color as well as energetic
strokes to bring that space forward.*

The Practice of *Translating*

Meditation

Take three full breaths to release bodily tensions and thoughts, and to relax into the present moment. Close your eyes and imagine that your third eye (between your eyebrows) is opening wider. This is your eye of intuition. It is able to see the big picture and know what is most important and what is extraneous. State your intention: Let what is most important here be revealed.

When the natural relationship between mind and body is allowed to flourish, it becomes the sacred marriage of our male and female energies, our yin and yang. From the dynamic balance of their union, all the gifts of spirit are brought forth. In the yoga of drawing, it is this proper balance that allows us to see and then to know.

When you draw, if you allow Body Mind (right brain) to direct and begin the process, then Logical Mind will be free to give its two most powerful gifts: simplifying and choosing. I make this point here because at this stage in the drawing process, issues begin to be larger than the particular thing you are drawing. Whether it is a study that remains in your notebook or one destined to become a finished and framed drawing, the decisions you now make have to do with declaring some kind of thematic statement.

For instance, you may have begun drawing a particular woman wearing a hat. You began in Body Mind, getting the gesture only because "something" intrigued you. But as you continue, you begin to recognize that it is the echo of circular shapes of hat and skirt and round rug that are exciting you. This is Mind, simplifying the details into a meaningful pattern that is uniquely your perception of that woman. Thus the experience is wider now, including you as perceiver, as well as your subject.

The act of simplifying in its natural progression has helped you to discover what it is that excites you. Now you're ready to translate that knowing into the choices that will make this your unique study as you choose what to leave in and what to leave out. In assimilating what you've learned, it becomes your own, and now you begin to feel comfortable making new decisions based on the needs of the situation.

As your mind begins to see what's most important, your drawing will find both its physical and thematic focus. The hat may be the focus, but the texture of the straw may become what intrigues you, and that factor will govern all other decisions about the space, objects, or elements of visual harmony that surround and lead you to that focus. It is the medium of your mind, now a shining knight with a sword of decision, that cuts away the nonessentials and chooses only that which is in service to his lady.

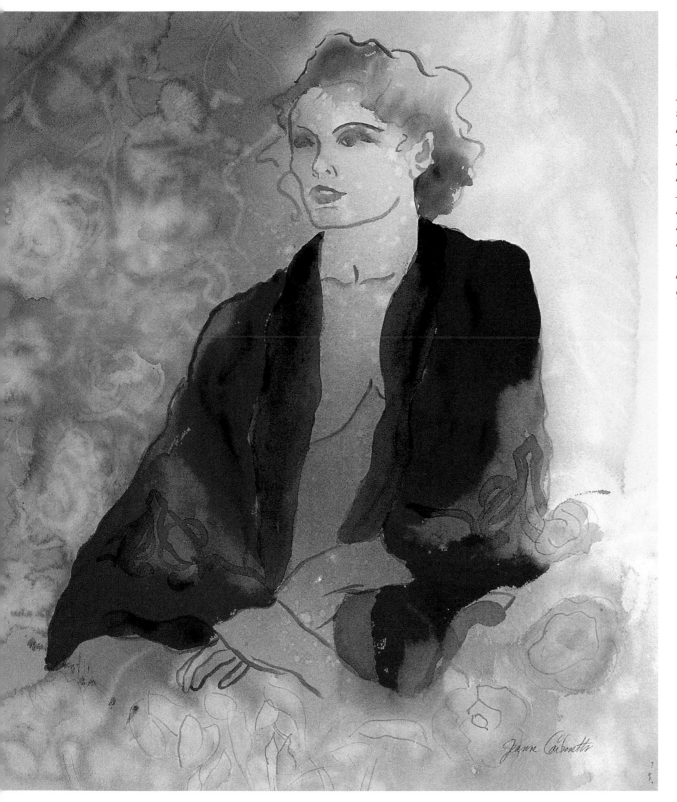

Jeanne Carbonetti
Victoria's Robe
Watercolor on toned paper,
25 × 20" (64 × 51 cm), 1998.
Collection of the artist.

*I wanted this piece to sit
right on the rim between
drawing and painting. The
woman's form is carried by
line while the robe is carried
by the modulation of paint.
I did the same thing with
the flowers. In the upper left
they are painted, while on
the bottom, they are drawn.
"When is it painting or
drawing?" is a beautiful
question that I chase often.*

Principles of Visual Harmony

Zena Robinson
Winter Trees
Watercolor, pen and ink on paper,
7 × 5" (18 × 13 cm), 1998.
Collection of the artist.

Zena had this watercolor wash filed away for some time, waiting for an inspiration as to how it might be used. One day she saw some hillside pines and knew they belonged to this wash. What was most important in her approach was what she left out, allowing the delicate watercolor its part in the telling of the story.

Every extended study or finished drawing requires the same attention to the principles of visual harmony—focus, composition, value, color, and texture—as a painting demands, even if your drawing is of a single figure with no indication of an environment. Let us explore each of these principles to see how they relate to drawing.

Focus

The place that attracts the viewer's eye first is the focal point of a drawing, the anchor to which everything else is linked. Once you have your focus, all your decisions are made in reference to it. Focus is also the story and theme of the piece. Your focus in a landscape drawing might be one particular section of a maple tree; the theme might be its sturdiness. Recognizing this, all the other choices made in your process will be toward telling the story of this sturdy maple.

Composition

The next principle of visual harmony is composition: how all positive and negative spaces in your drawing relate to one another and to the shape of the whole. More than any other element, composition leads you to or away from your focus, because it entails manipulating forms to create the world of your drawing and its vantage point. Some artists like to be up close to things, very concentrated on foreground objects; some prefer working at middle distance; others favor deep distance, taking in perspective that includes distant objects.

Value

The lights and darks of your drawing constitute its value range. Light values and dark values always attract the viewer's attention, leading the eye toward your focal point. Since value establishes the shading and volume of objects, you can see how selective you must be in order to lead the eye where it needs to go. Should your next drawing be light (high key) or dark (low key)? Do you prefer lots of white space, as in contour drawing, or dense coverage with many gradations of value? These are decisions to be considered as you determine value in each drawing.

Nancy MacKenzie
INTERIOR VIEW
Pen and ink on paper,
10 × 8" (25 × 20 cm),
1996. Collection of the
artist.

*In this interior view with
many parts, Nancy's skill
of selection shows itself in
the areas she deliberately
develops and those she
leaves spare. Detailing the
corner pillow with pattern
seemed a perfect touch
to balance the wall art
peeking in over the sofa.*

Jeanne Carbonetti
ORIENTAL LILIES
Pen and ink with wash on paper,
12 × 11" (31 × 28 cm), 1998.
Collection of Anne Bergeron and
Glynn Pellagrino.

*There is something about the
fluidity of pen and ink that lends
itself perfectly to following the
flowing movement of flowers.
Even physically, a pen with ink
can match the fluid dance of shapes
as your eye follows every contour.*

Color

Often as integral to a drawing as to a painting, color can swing the mood of artwork easily.
Cool blues, greens, and violets are generally quieting, while warm reds, oranges, and yellows
are more energetic. A single hue in different values, monochromatic color, can be quietly
dramatic, while consecutive rainbow hues, analogous color, can be very fluid in nature. Hues
that are opposite each other on the color wheel, complementaries, can be dynamic, often
producing eye-popping effects, and primary colors—red, yellow, and blue—can be equally
powerful next to each other in equal doses. How you gravitate toward certain colors is
important for you to observe, because it may indicate your special place on the scale
between graphic drawing (interest in line) and painterly drawing (interest in modeling).

Texture

Texture refers to both the feel of an object and the feel of the medium used to portray it. It
involves the stroke itself—its heaviness, softness, swiftness, slowness, grace, or angularity, and
the feel of the paper, canvas, or other support on which the drawing is created. The medium
itself, such as Van Gogh's calligraphic notations in his drawings, can evoke as much interest
as the subject itself. Are you attracted to such drawings, where the hand of the artist is as
powerful as the subject? Or is your predilection toward more diagrammatic drawings, where
the subject is the featured story? Recognizing your own preferences will help you to know
yourself as an artist, and, in turn, aid you in creating drawings that are as much about your
heart as about the heart of the subject.

The Art of *Composing*

Materials

- soft and hard pencils
- tracing paper
- drawing paper
- marker
- #10 waterclor brush
- sumi-e ink or black watercolor

In a series of short studies that can be extended to longer ones, use the same subject to move from a distant view to a middle distance view to a closeup. Follow the usual procedure, going from gesture to contour for each of the three studies. Try a pencil still life, a figure with a wash, and trees drawn with sumi-e ink or black watercolor, then see which study intrigues you the most. Your choice will hold an important clue to your special way of translating visual experience. This by no means implies that you have found a formula for "manufacturing" images, but it does provide a clue as to your nature as perceiver.

Extended Study, Still Life. Use your short study of a still life as the basis of an extended study that should take about twenty minutes. As you enlarge your composition, be aware of the arrangement of shapes to the space around them and to each other. In the larger format, does it work as well? Feel free to rearrange relationships if necessary. Be mindful of how much you really manipulate the image. This tells you how important the whole context is in drawing, and how much choosing is really going on.

Extended Study, Figure with a Wash. Allow about an hour for this extended study as you use a wash to play with the space around the figure. Compose the drawing as you desire, being mindful of the elements you wish to include. After you have recognized your real focus, use the wash to direct your eye and to provide the sense of depth desired.

Extended Study, Sumi-e Trees. Allowing about twenty minutes for this study, it's preferable to work from nature, but a photograph (not a drawing) will do. Practice choosing the essential line. Feel free to do any kind of gesture first. Then, with a pause between each stroke, let each stroke count, not only toward delineating your trees, but also toward completing your composition by addressing the edges of the paper so as to imply spatial relationships.

Jeanne Carbonetti
ANNIE'S DELPHINIUM
Pastel on toned watercolor paper,
27 × 20" (69 × 51 cm), 1998. Collection of the artist.

This is a gesture drawing done in pastel. The broad tip of the chalk allowed me to stay big, broad, and bold. I experimented with many strokes to see which would give me the greatest feeling of exuberant energy and abundance. The dashes of white were an equivalent in chalk to spatters of white watercolor.

Michelle Holt
SUMMER LEAVES
Pen and ink with wash on paper,
16 × 7" (41 × 18 cm), 1998. Collection of the artist.

There was a lot of choosing and changing in executing this drawing. Michelle first blocked out three major bands of wash in the background to take the place of real space, then she eliminated any leaves and branches that appeared extraneous. Note how even her box became an ornamental element in the final composition.

Alexis Kyriak
ADAM AND EVE
Pencil on paper, 22 × 15"
(56 × 38 cm), 1993.
Collection of the artist.

Watching Alexis work is a
fascinating process. In pencil
drawings such as this, she
usually begins with a curved
stroke, then twisting and
turning her lines, she quests
to break free, always seeking
fresh discovery as she proceeds.

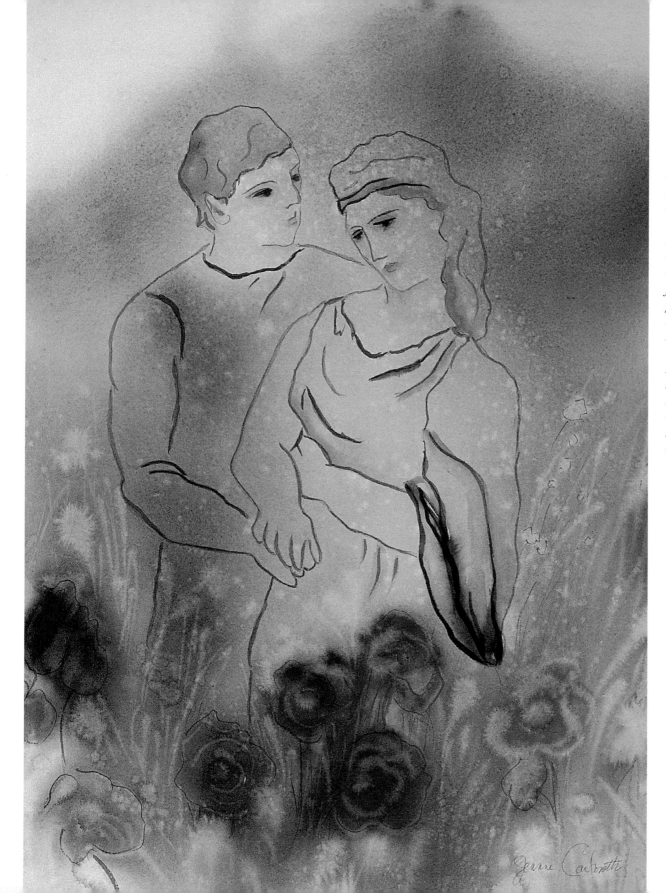

Jeanne Carbonetti
Picasso's Lovers
Pen and ink with wash
on paper, 25 × 20"
(64 × 51 cm), 1998.
Collection of Anne
Bergeron and Glynn
Pellagrino.

*I designed this piece for
the wedding invitation
of my friends Anne and
Glynn. They asked for
two figures, a mountain,
and a lake, which quickly
brought to my mind two
figures of Picasso's classical
period that represented
the perfect archetypal
symbol of matrimony.
With that as inspiration,
I approached the drawing
as a graphic design rather
than a realistic vista,
which I felt would
heighten the sense of
intimacy.*

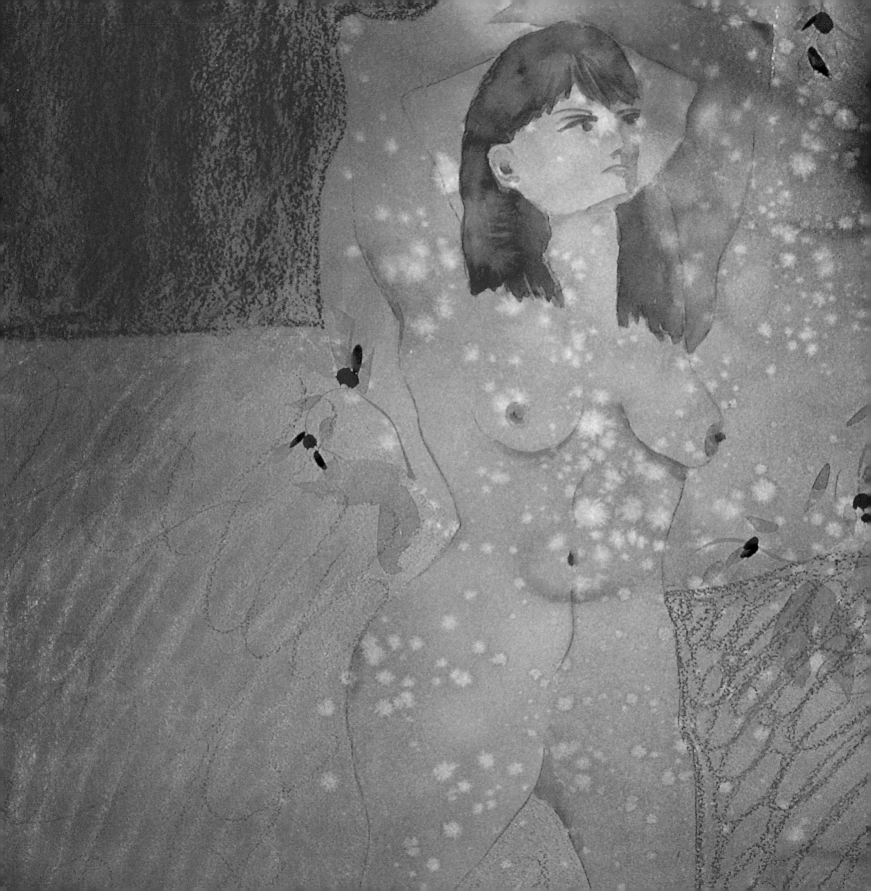

Expressing

Great dancers are not great

because of their technique;

they are great

because of their passion.

Martha Graham

Jeanne Carbonetti
I Dream My World
Into Being (detail)
Watercolor and pastel on paper,
30 × 22" (76 × 56 cm), 1994.
Collection of the artist.

This is more a drawing than a painting,
for the medium of line actually carries
the story. The use of pastel to scribble in
large blocks provided an energy to match
the power of this woman. Sometimes
strange bedfellows make good marriages.

The Practice of Being Yourself

Meditation

Take three full breaths, allow yourself to sink into relaxation, letting tension of every kind release. Picture a wide-eyed, exuberant child of three or four in the shelter of your heart. You will draw with that child today. As you allow that child complete self-expression, give yourself the same. State your intention: I allow my heart child complete and free self-expression; I allow myself the same.

Spirit is that which is intangible on a physical level, yet quite palpable on a perceptual level. All parts of creation express that uniqueness constantly—especially human beings, as our birthright of consciousness makes us funnels of the life force.

Artists are keenly aware of this funneling process. Whenever we create art, we make a host of decisions in translating what's out there to our chosen medium and form. The student of drawing realizes early that line itself is an abstract convention. When we draw, we move from a pinpoint of concentration on our subject to a wider perception as we simplify, choose, and establish a theme or mood.

In the art of realistic drawing, then, the issue is one of finding balance between recording and expressing, a broad spectrum that offers many choices. The challenge is finding the right one for you, recognizing the special way you see and manipulate forms to produce drawings that are uniquely yours and not someone else's. In the search, the only danger is jumping the gun, trying to get there too soon, forcing your drawing into a mold that becomes a formulaic style. Instead, if you will be yourself as you seek to know, you will come to express yourself as naturally as a playful puppy, continually stretching and growing.

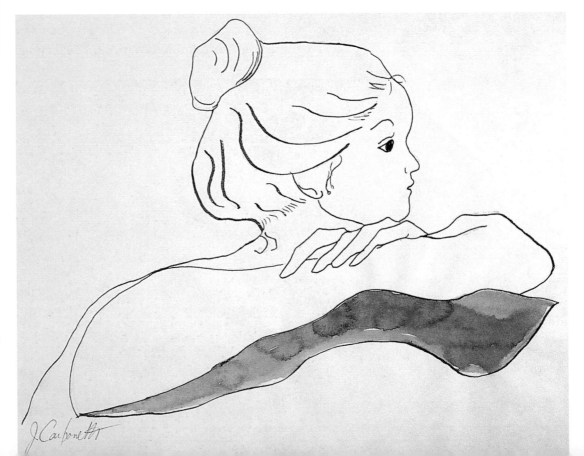

Jeanne Carbonetti
STUDY OF A GIRL IN BRONZE
Pen and ink with wash on paper,
8¹/₂ × 11" (21 × 28 cm), 1984.
Collection of the artist.

Inspired by a bronze sculpure that I admired in a magazine photo, I found the graceful rhythm of hair, arm, and hand so complete that I felt one simple wash would accentuate the form, while more than that would detract from it.

Being yourself as you draw means learning to *see yourself* in your drawings. Only then will you begin to trust yourself, relax, and be less likely to fall into formulas. It means learning to read both your work and your process, learning to recognize what excites you.

I have found three areas of picture-making to be instrumental in getting to know myself as artist. First, the principles of visual harmony, discussed in the previous chapter; second, the spectrum between abstraction and realism; and third, the mediums I choose for self-expression.

Finding the Balance Between Abstract and Real

Knowing your preference for abstraction or realism is a way of uncovering your true expression along the spectrum from pure abstraction (no recognizable forms) to pure figurative realism (completely recognizable forms). It is from this reference that you view the world and translate it into your art, expressing what you love about what you see. For example, I'm high noon between abstraction and figurative realism. In both painting and drawing, the outward form inspires me first, so that's where I begin. But then I look for the inner essence of that form.

One of the best ways to discover your predilection is by scanning art history books. Ask yourself what you would want to hang in your living room. The answer should help override any tendency to confuse your admiration for technical facility with your true aesthetic preference.

Jeanne Carbonetti
THE OPEN ROSE, CONTINUED
Chalk pastel on paper, 15 × 16"
(38 × 41 cm), 1998. Collection
of the artist.

In ten studies of a rose, I began with a very clinical rendition of the flower and ended with this one. In moving from what the rose looked like to what it felt like, I finally came to the core of me as well.

Choosing Your Medium

Finally, seeing yourself in your drawing also rests on the medium you choose to work with. The primary issue in choosing a medium for drawing is to understand the difference between painting and drawing. It's simple: Drawing is concerned with line; painting is concerned with modulation. In general, drawing uses dry mediums, so that line is preserved, while painting uses wet or soft mediums, where forms can merge with the atmosphere around them.

Dry Mediums include:
- graphite ("lead") pencils—from 9B (softest) to 9H (hardest)
- carbon pencils—very soft
- charcoal pencils—cleaner than charcoal sticks
- colored pencils—hard, permanent, lightfast
- pastel pencils—wood-encased, neat, clean
- hard pastels—firm, dustless

Wet Mediums include:
- sumi-e ink for line and wash—water-soluble, permanent black
- watercolor (often used to "color in" drawings)—used dry or very wet and transparent so lines show through

Jeanne Carbonetti
MODEL IN DUSTY PINK
Pencil and marker on paper,
7 × 13" (18 × 32 cm), 1982.
Collection of the artist.

There was a quality about the model against a blank wall that attracted me, and the line of molding became an important design element in this piece. Shading her in pink seemed a more appropriate way to show the delicacy of the form against the white, rather than using the gray of the pencil for shading.

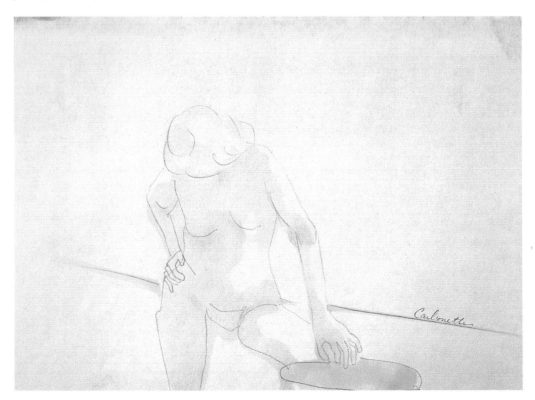

Combination Mediums include:
- charcoal with gum binder—for very soft effects
- charcoal powder—most painterly effects
- water-soluble graphite pencils—subtle painterly effects
- sanguine—reddish brown chalk
- conté chalk (stick/pencil)—earth colors
- soft pastel—strongest pigment of all pastels
- water-soluble pastel pencils—for painterly effects
- oil pastel—strong pigments, very blendable
- oil sticks—paint/paste/wax mixture

The Art of the Mood

Materials

- drawing paper, colored or white
- 3 different drawing mediums
- tracing paper for transfer
- red marker (for transfer process)

Mood is the visual counterpart to spirit. It gives you nonspecific yet essential information. It is the interface between artist and subject, and the vehicle for the artist's expression.

The studies that follow are all designed to help you see where your subject leaves off and you begin.

Carmen Fletcher
Man in Long Robe
Sumi-e ink and brush on paper,
11 × 8¹/₂" (28 × 21 cm), 1997.
Collection of the artist.

Carmen's love of texture gets free play when she uses brush and sumi-e ink. The medium allows her to go thick or thin very easily. Her varied strokes give expression to the hair and face, the connections of the figure to the chair, and even the sense of shelter by an imaginary chair.

Study in Abstraction. Allow thirty minutes for this exercise. Using a drawing that you rendered as a full-volume drawing in a previous chapter, abstract the piece by simplifying it into its essential lines, shapes, values, and/or textures.

Watching Yourself in Process. During any three studies of your choice, watch yourself work, noting when you feel in synch, when you do not, how you ease into connection with your subject, and anytime when you get bored or frustrated. Make notes after each study. Then compare the three sessions. Are there patterns to your process? For example, do you always get bored doing volume drawings? Do you try to jump over gesture drawing and then stay restless for quite a while in contour drawing? How long are you able to concentrate? Your sign of comfort or discomfort is a clue as to what to change, what to keep.

Carmen Fletcher
Two Friends in Paris
Monoprint with charcoal on paper,
20 × 15" (51 × 38 cm), 1989.
Collection of the artist.

Carmen's love of texture comes through in every varied stroke of this study. Look at several of your own drawings. What is their common denominator?

Marilyn Clough
MODEL WITH TURTLENECK SWEATER
Pen and ink with wash on paper,
22 × 15" (56 × 38 cm), 1998. Collection of the artist.

Finding your special recipe for using the principles of visual harmony—focus, composition, values, color, and texture—helps you refine your personal vision. Marilyn found that fluidity was an important textural component for her, indicating a strong theme of merging.

Alexis Kyriak
SAINTS EVERY ONE
Pastel on paper, 30 × 22" (76 × 56 cm), 1992.
Collection of Jeanne Carbonetti.

Alexis's work comes from a strong background in theology, but it's obvious that she brings a very personal interpretation to it. In this pastel, she sought to explore the sacredness of human life. For Alexis, what is sacred and what is profane remains life's beautiful question.

Live Studies of a Motif. Allow one hour each for three studies of the same genre: either three different figures, three outdoor scenes, or three still lifes. These can be done over a period of time, but it's important to date them.

When you have a group completed, look at the three together. Do you see an evolution taking place? Go through the visual principles of focus, composition, values, color, and texture, and compare them in each category. What you see is your own natural growth as an artist.

Zena Robinson
Nature's Umbrella
Pen and ink on paper, 4 × 6" (11 × 16 cm), 1996.
Collection of the artist.

Important to every artist is a feeling for a special medium and a special stroke. Both become signatures for us precisely because their technical aspect supports our thematic vision. Here, Zena explores many ways of using her pen, which while beautifully rendering the tree, does not fail to express her own playful spirit as well.

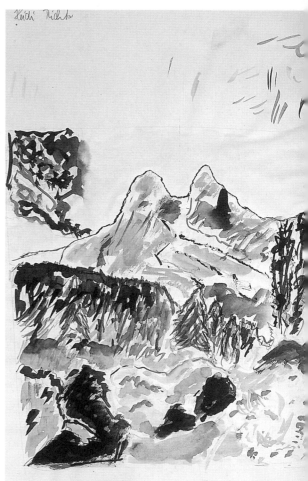

Heidi Richter
Landscape in Black and White
Sumi-e ink and brush on paper, 15 × 12"
(38 × 31 cm), 1998. Collection of the artist.

The calligraphy of Heidi's stroke is an important element in her expression, and it comes under the category of texture. Here she uses varied lines and marks to indicate shape and direction, while she employs value to indicate depth of perspective.

90

Jeanne Carbonetti
FUNNY FIRS
Pastel on toned paper, 8 × 8" (20 × 20 cm), 1998. Collection of the artist.

This piece began as a much tamer version of mountain landscape and trees. When the blocking of composition called for a bolder approach, I used color and texture to carry the theme. First, I introduced color that was strong and expressive, rather than descriptive, then I used a gestural approach to give added texture and life to my trees.

Exploring

It is only with the heart

that one sees rightly.

Antoine de Saint Exupéry

Alexis Kyriak
ANGEL DESCENDING
Pastel on paper,
20 × 16" (51 × 41 cm), 1996.
Collection of the artist.

*Alexis works from her very core. She
begins with pure expression, much like
a child at play, but then the mother and
father in her join the child and bring
the work to completeness, joining body,
mind, and spirit in flawless rhythm.*

The Practice of Exploring from Within

Meditation

Using three full breaths, relax into the present moment, releasing all tensions. Close your eyes. Imagine a large movie screen in front of you. Watch a movie of your most fervent dream, unfolding and coming true on that screen. When you feel ready, enter the picture—put yourself right up there on the screen, so that you are simultaneously viewing it and living it.

Did you allow yourself a wonderful daydream meditation? Now you're ready to go exploring on paper.

In the practice of yoga, it is well understood that we must allow our body to express itself as naturally as possible before any deeper levels of exploration can unfold. To stretch into greater dimensions of the self, first we must become comfortable with our own limits.

This relationship of expression to exploration exists in the art of drawing. As artists, we begin to understand our own special way with the principles of visual harmony as we see them appear through many drawings. This, in turn, gives us the tools to go deeper, to further our evolution. Drawing becomes a means of searching from the inside out, of using ourselves as our subject. The benefit of this is a greater sense of what we bring to the drawing table and a deeper partnership with all we draw.

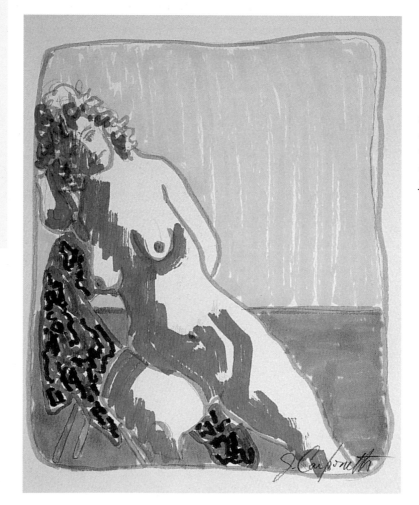

Jeanne Carbonetti
MODEL IN VIOLET AND YELLOW
Colored markers on paper,
12 × 8" (31 × 20 cm), 1991.
Collection of the artist.

This exercise with markers helped me to see that although the drawing had a certain appeal, too much color can detract from the contour and diminish the effect of the empty, yet full, space I so love.

Searching Yourself

How do we turn the looking glass back on ourselves? Begin with no form whatsoever, and allow it to emerge. It can be a thrilling experience to plunge into a sea of strokes and smudges and then start to feel the pull toward form. The form that pulls you forward is always a deeper level of your seeing, of your knowing, and it trains you to be a more powerful partner with other subjects, because you have now turned the mirror toward yourself. As your own reflection becomes clearer, so does the world that you draw.

In exploring with strokes and smudges, play with pure line at one end of the spectrum, and pure tone and modulation, with no line at all, at the other end. Of course, there are many places in between, and pushing the limits of one medium until it crosses over into another is a powerful way of experiencing your deeper perceptions. When you do, you'll find a pattern to your playing, a comfort zone that holds the keys to both your process and your personal vision. For it is a curious and lovely paradox that when we go deep within ourselves, we come to a greater awareness of the world, and in drawing our world, we always see ourselves.

Carmen Fletcher
SUNFLOWER
Sumi-e ink and brush on paper,
12 × 7" (31 × 18 cm), 1997.
Collection of the artist.

This is a classically rendered sumi-e drawing. After the initial spill of ink on paper, every stroke is deliberately drawn in response to the one before.

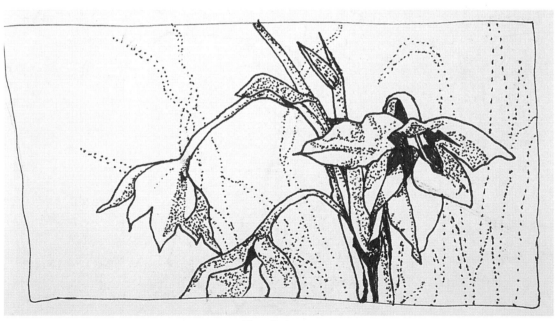

Zena Robinson
DAYLILIES
Pen and ink on paper, 3 × 7" (10 × 18 cm), 1996.
Collection of the artist.

Each medium and tool we use has many ways to give its gift. Zena, who loves pen and ink, is always finding new ways to work with her instrument to say different things. Here, she uses large dots to indicate soft-focus flowers, and concentrated, smaller dots to suggest shading.

Exercise: The Art of Imagination

Materials

- any dry drawing medium that appeals to you
- any wet painting medium that appeals to you
- paper that can take a wet as well as dry medium
- tracing paper for transfer (optional)

A body of literature in the field of energy research suggests that the faculty of imagination may actually be an organ of perception. Certainly artists have always understood that imagination is an important element in the creative process. Yet the notion that imagination may be a key to unlocking our personal filter of reality and with it, our special gift, may be a new and even comforting concept to many.

Can it be that as creative people, often viewed as eccentric or odd, we are simply perceiving on a higher frequency that allows us to see deeper than others?

What this means for the student of drawing is that there may be as much meaning in drawing the *inside* of a thing as in drawing the outside. This exercise is based on that premise.

Mixing Mediums. Allow about one hour for this study. Use a subject you've drawn before, but now, apply both drawing and painting techniques; that is, allow for form to be represented both through line and drawn shadow as well as through the modulation of tones in a fluid medium.

Notice what feels good and what doesn't. Does the mixture of mediums help or hinder you? Do you have the sense of "crossing the line" and emphasizing one more than the other? Your response to these questions will be a clue as to why you draw in a particular way.

For example, I love to mix the fluid wash of watercolor with line drawing. This is because I see space itself as being full, and I see all forms as being translucent to this same fullness. Filling things in, then, doesn't appeal to me, because it goes too far in description.

Chest of Symbols. Allow about forty-five minutes for this study. Begin by closing your eyes for a short visualization. Imagine that you find yourself in a lovely space that has a treasure chest with your name on it. It contains gifts from your guardian angel. Draw the gifts and whatever else in the picture seems appropriate.

By the time you've finished this exercise, you will have made a complete circle in the journey that is drawing: through a deep connection to your subject, you have moved on to a deeper connection with yourself. This is the union of yoga. The body is the place for spirit, and it always leads to where the two are one—in the heart.

Jeanne Carbonetti
ANNIE'S GARDEN, AGAIN
Pastel on toned paper,
25 × 22" (64 × 56 cm),
1998. Collection of
the artist.

This piece began as a
watercolor but it just
never came to resolution.
Then one day I realized
it needed texture, and
I suddenly saw it as a
pastel. I used the painting
beneath my blueprint,
so to speak, and let the
pastel take over.

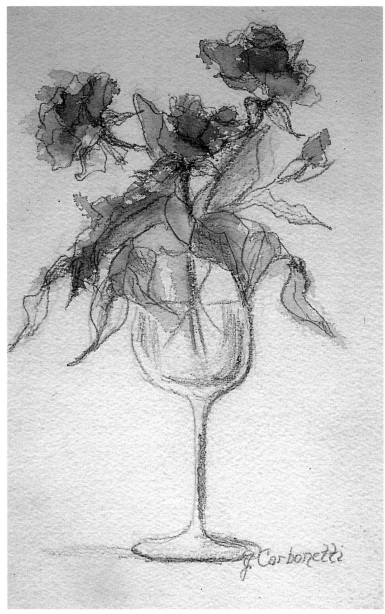

Jeanne Carbonetti
ROSES IN A GLASS
Pencil and wash on paper,
8 × 4" (20 × 11 cm), 1980. Collection of the artist.

I'm always attuned to the special personalities of different mediums, and I find that they often lend themselves to just the perfect collaboration for my needs. Here, a splash of wash served to smudge the drawing just enough so as to create the delicacy I was after.

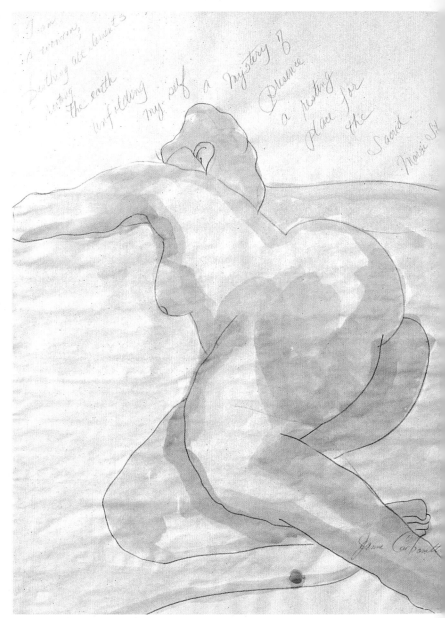

Jeanne Carbonetti
I AM WOMAN
Pencil with wash on paper,
20 × 16" (51 × 38 cm), 1990. Collection of the artist.

I've always loved this pose of the model, for it speaks of a woman completely at home her body. In this piece I actually focused on the lights (the yellow), rather than shadow

Jeanne Carbonetti
CHERRY TREE
Pastel and ink on paper,
12 × 7" (31 × 18 cm), 1998.
Collection of the artist.

What seemed beautiful to me about this tree was the rhythm of lights and darks in its foliage, so I chose to accent that feature, playing down the grass and flowers beneath.

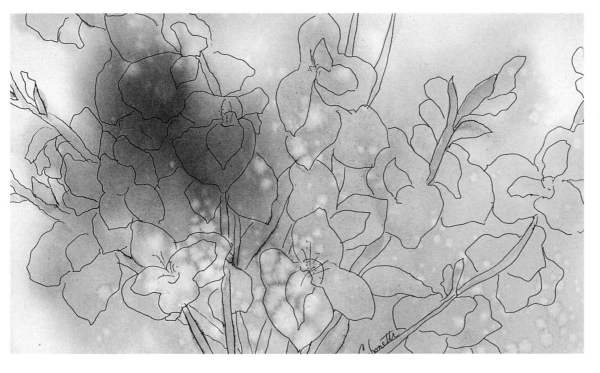

Jeanne Carbonetti
Sunlight on Glads
Pen and ink with wash on paper,
6 × 10" (16 × 25 cm), 1998.
Collection of Michael and
Marianne Jerome.

At my favorite inn, in Cooperstown, New York, hosts Mike and Marianne always keep a pot of beautiful fresh flowers at the entry. That display feeds my spirit whenever I see it, and has inspired several studies, each emphasizing some aspect of the pleasure I experience during my visit.

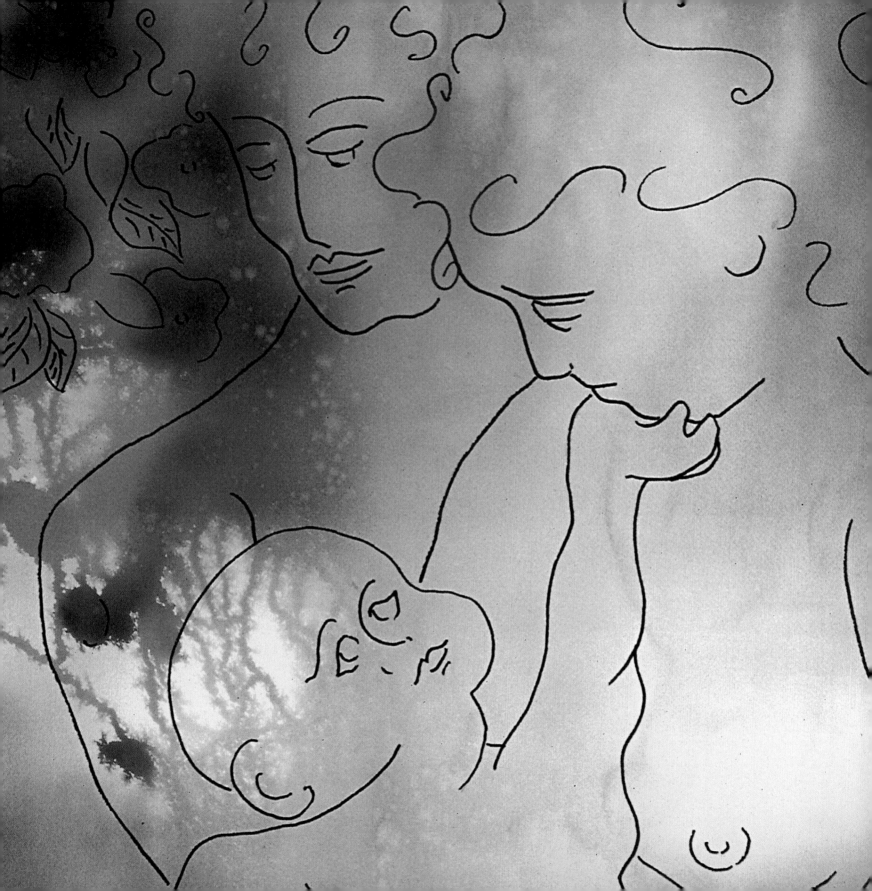

Loving

Beauty will save the world.

Fyodor Dostoyevsky

Jeanne Carbonetti
THE FAMILY (DETAIL)
Black marker on toned paper,
25 × 20" (64 × 51 cm), 1993.
Collection of the artist.

*This is an imaginary piece inspired in part
by the pose of figures in a Mary Cassatt
painting. I admired the Picasso-like turn
of the child's head, so I continued the play
on Picasso by outlining the wash to become
flowers. This family has since become a
symbol to me of Body, Mind, and Spirit.*

The Practice of *Communion*

Meditation

Allow yourself to sink into relaxation through deep breathing. Draw your attention to your heart. Imagine a rosebud there, and as you gaze at it with the warmth of your love, it opens into a glorious, fragrant flower. You look closer, and at the very center is an eye. You smile, for you know this is the most penetrating and powerful sight one can develop. This eye can see beauty beneath all things.

The goal of both art and yoga is always union. In art, our desire is to unite with the beauty and truth of that which is outside of us and yet speaks to us. In yoga, our desire is to unite our body, mind, and spirit, becoming one whole. In both disciplines, the practice of attention opens to a wider experience of contemplation, which then opens wider still to an experience of communion. It is the two eyes of sight becoming the third eye of insight, and the result is always love.

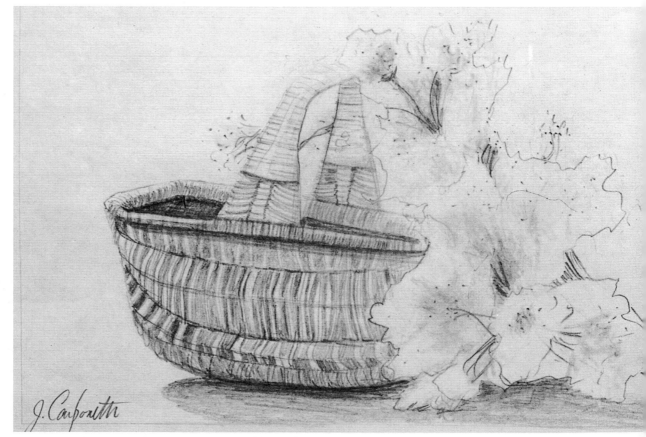

Jeanne Carbonetti
Basket with Puffweeds
Pencil on paper, 10 × 7" (25 × 18 cm), 1979.
Collection of the artist.

Some subjects just ask to be handled in a certain way. Although I lean toward contour drawing with pen, this hardy little basket just said it needed shading with a pencil. Listening to your subject is as important as looking at it.

Attention that moves beyond the ego to a larger framework of seeing, knowing, and understanding is a movement toward removing the mask, not just of your subject, but of yourself as well. It's an attention that doesn't judge; it receives.

Alexis Kyriak
Treescape
Pastel on paper,
30 × 22" (76 × 56 cm), 1996.
Collection of the artist.

There is a vitality and movement in Alexis's work that demands the simplicity of blocking. Here, she creates great movement toward an unknown center through a series of diagonal wedges, yet she is careful to balance the piece by anchoring it with the large blue wedge at the base and the larger trees at the left.

This is the key to drawing: to accept unconditionally, without making quick assumptions, either about your subject or about yourself—allowing yourself to be vulnerable and your subject to be full of surprises. Yet this is the one obstacle that keeps so many from excelling or enjoying the art of drawing—the inability to surrender to the moment, to release that sense of control and the need to judge.

As in yoga, I believe it's possible to use your body in drawing to ease you into this delicious surrender, and I hope your practice of the special order of gesture to contour described in this book helps you to experience its naturalness. The following principles are helpful aids to staying in this mindset.

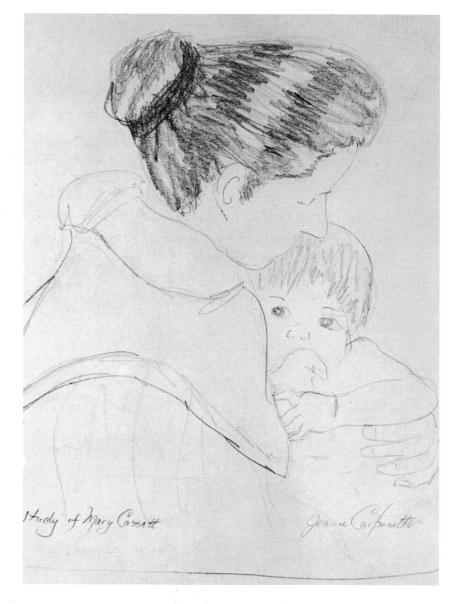

Study of Mary Cassatt

Jeanne Carbonetti

Principle Versus Formula

There is a difference between the principle of seeing and a formula for drawing. Formulas are static, principles are adaptive. A formula for drawing a barn, a tree, a face, will take you only so far, for every barn is different, every tree unique, every face distinctive. Once you understand the principle of drawing anything, you are equipped to handle every exception, including changes in perspective and foreshortening. Thus, a rose becomes *this* rose, and then it becomes a representation of *all* roses, and finally, it becomes *your* rose.

Having Innocent Eyes

Pretend, whenever you draw, that you've just arrived from another planet and are seeing your subject, and anything like it, for the very first time. Look with this kind of wonder and innocence, and you'll avoid jumping to conclusions and drawing what you think you know instead of what you see.

Search and Surprise

Drawing is seeking to know and understand, an attempt to find the pattern of truth within. The artist's mind is thus more malleable, more vulnerable, more open to surprise, to change. This is the most important distinction between thinking and doing, versus feeling and being.

A Line Is a Caress

Drawing is like poetry, in that one line can say more than one thing. Like the poet, the artist must be selective and able to manipulate the language of line to say what needs to be expressed. Remembering this will help you to maintain fresh perception, rather than resorting to manufactured image, more slick than real.

Embracing the Whole

From beginning to end, the whole is more than the sum of its parts. Seeing the whole space will help you draw each part of your composition in relationship to it, and embracing the whole as you proceed will give your drawing a unity of spirit and expression to make it distinctively yours.

The Ability to Feel

All art speaks the language of the heart, and its vocabulary is feeling. As you grow in the beautiful balance between your impulse to record and your impulse to express, you will open more and more to the understanding that comes through your feelings, and this will provide the power of your picture.

Seeking New Forms

I'm not suggesting that you experiment just for the sake of being new and different—but I don't think you should rely only on what has been successful for you in the past. Instead, as you naturally evolve, you'll want to find new ways to say what you need to say, and perhaps try new mediums to aid that expression. Follow your instincts—allow yourself to experiment.

Talent Evolves

Let me share with you a wonderful and curious discovery I've made through my years of teaching. Many students want to know, before they begin lessons with me, if they have talent. In every student's work I have seen, there is always an element present that I know can be a powerful voice of artistic expression, if it is allowed to evolve. It is invariably there, and it has made me realize that without exception, we each have the seed of creative genius within us.

Creativity is, indeed, your birthright. The fact that you are reading this book attests to your desire to release and develop your creative powers to their fullest. Know that the seed of genius that is assuredly yours will flower in the presence of the kind of desire that keeps you trying, again and again. It is your *desire* that is the true talent.

When I see natural ability, I smile, but when I see great desire, I cheer, for I know an artist is being born.

Exercise: The Art of Bliss

Materials

- your eyes
- your heart

The ritual of communion has always been a beautiful experience for me. As I take the bread and wine, it is a symbol of complete union, wherein I take the body of another so wholly into myself that we are both transformed, and the I that was me becomes the I that is we.

This beautiful symbol of the release of separateness is paralleled in yoga and, in the exercise that follows, as the release of the separate, smaller mind into the universal, larger mind, like a drop of water that recognizes it is ocean and allows itself to flow back into its greater power. The sense of release has a quality of momentousness about it; you suddenly feel you are seeing another level of reality. In fact, you are. You no longer see with the two eyes of the ego but with the single, third eye of self, an exalted experience, like making love.

For making art is always making love, and the act of drawing is no less than a caress of the beloved. I promise you this: If you practice the art of drawing, the world will grow more beautiful before your very eyes. It will never be the same again, and neither will you. For this is the path of bliss—the union of body, mind, and spirit. It is the one behind the many, and the true nature of every creative life.

Developing the Eye-Heart. Allow yourself a lifetime. As much as you can, and as often as you can, look upon whomever or whatever you are with *as if you are drawing it.* Receive your subject fully, pause before judging it, and allow yourself your own full expression. Your practice will make the world more perfect, and you will grow in the wisdom to see beauty beneath all things.

Jeanne Carbonetti
THREE PITCHERS
Pen and ink with wash on paper,
9 × 7" (23 × 18 cm), 1997.
Collection of the artist.

Nothing is too insignificant for special reflection. I love the full-bellied quality of these pitchers. Being with them was like being with three wise old women who had the capacity to accept all things as they are.

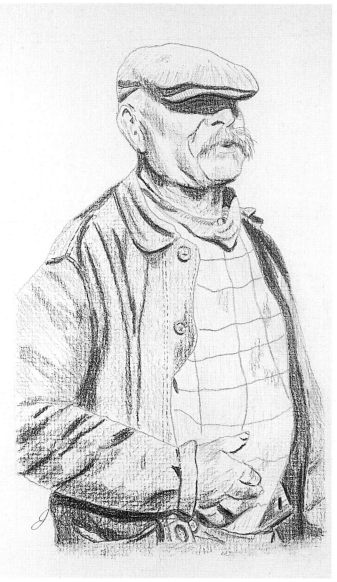

Jeanne Carbonetti
Study of a Country Journal Fisherman
Pencil on matboard, 13 × 7" (33 × 18 cm), 1980.
Collection of the artist.

The varied textures in a wonderful magazine photograph inspired this drawing. I felt that the granular quality of matboard would lend itself well to working in pencil and would produce a certain roughness to match this gentleman's strong presence. I always try to choose my surfaces quite deliberately to reflect the theme or mood of the piece.

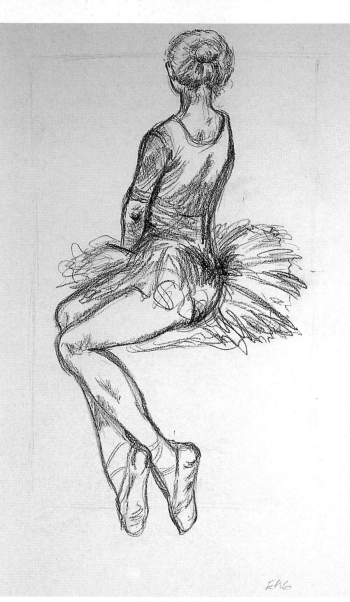

Elizabeth Gardiner
Study of a Dancer
Charcoal on paper, 22 × 15" (56 × 38 cm), 1998.
Collection of the artist.

A part of finding your personal expression in drawing is experimenting with your stroke. In this drawing, Elizabeth used smooth, even strokes to indicate shadows and very energetic lines to expresses the frills of the skirt.

Jeanne Carbonetti
WISTERIA II
Pastel and ink on toned paper, 15 × 15" (38 × 38 cm), 1998. Collection of the artist.

Sometimes it's important to throw yourself into a drawing just to see what you are really thinking. After ten versions of wisteria, I keep finding new areas to explore.

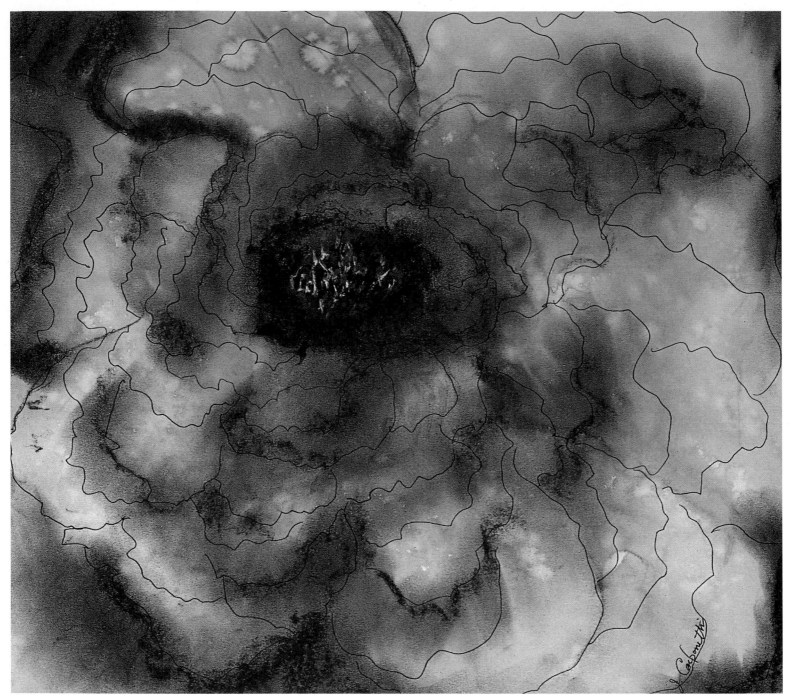

Jeanne Carbonetti
OPEN ROSE III
Pen and ink with pastel on toned paper,
10 × 11" (25 × 28 cm), 1998. Collection of the artist.

Things we love are worth many studies to discover just what excites us most about them. I've painted and drawn many roses, but each time, something new captures my attention. For years, rosebuds enchanted me. Now, I seem to be exploring wide-open petals that allow themselves to be fully exposed.

Recommended Reading

To continue your study of drawing, I suggest the following books:

Bowen, Ron. *Drawing Masterclass.* Boston: Little, Brown, and Company, 1992.

Cornell, Judith. *Drawing the Light from Within.* New York: Prentice Hall Press, 1990.

Edwards, Betty. *Drawing on the Right Side of the Brain.* Los Angeles: J. P. Tarcher, Inc. 1979.

Franck, Frederick. *The Zen of Seeing.* New York: Random House, 1973.

Goldstein, Nathan. *The Art of Responsive Drawing.* Englewood Cliffs, N.J.: Prentice-Hall, Inc., 1977.

Jacobs, Ted Seth. *Drawing with an Open Mind.* New York: Watson-Guptill Publications, 1986.

Nicolaides, Kimon. *The Natural Way to Draw.* Boston: Houghton Mifflin Company, 1941, 1969.

Index